ACRYLIC
PAINT
POURING

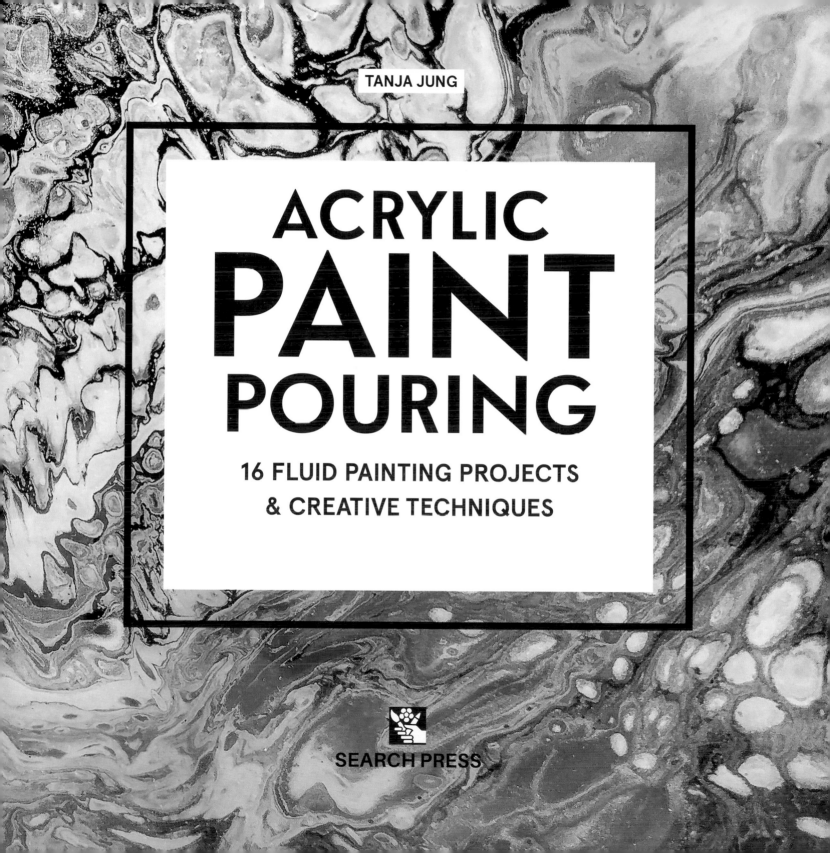

TANJA JUNG

ACRYLIC
PAINT
POURING

16 FLUID PAINTING PROJECTS
& CREATIVE TECHNIQUES

SEARCH PRESS

First published in Great Britain in 2020 by
Search Press Limited
Wellwood, North Farm Road
Tunbridge Wells, Kent TN2 3DR

© Edition Michael Fischer GmbH, 2018
www.emf-verlag.de

This translation of **Pouring & Fluid Painting**, first published in
Germany by Edition Michael Fischer GmbH in 2018, is published by
arrangement with Silke Bruenink Agency, Munich, Germany.

English translation by Burravoe Translation Services

ISBN: 978-1-78221-846-3

Picture credits
Photography © Tim Lachmann, apart from:
Page 108: © Bernd Weller; Image Page 13: © Marabu GmbH & Co.
KG; Colour wheel Page 15: © imagewriter/Shutterstock;
Cover: © Antonova Katya/Shutterstock

Text pages 12–13: Anita Hörskens

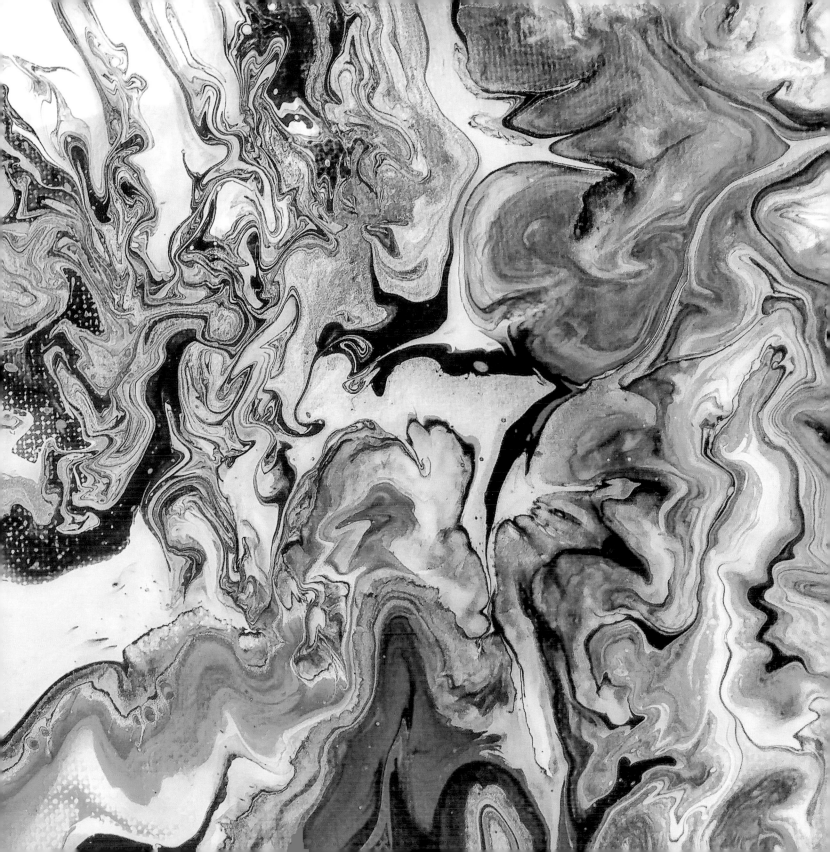

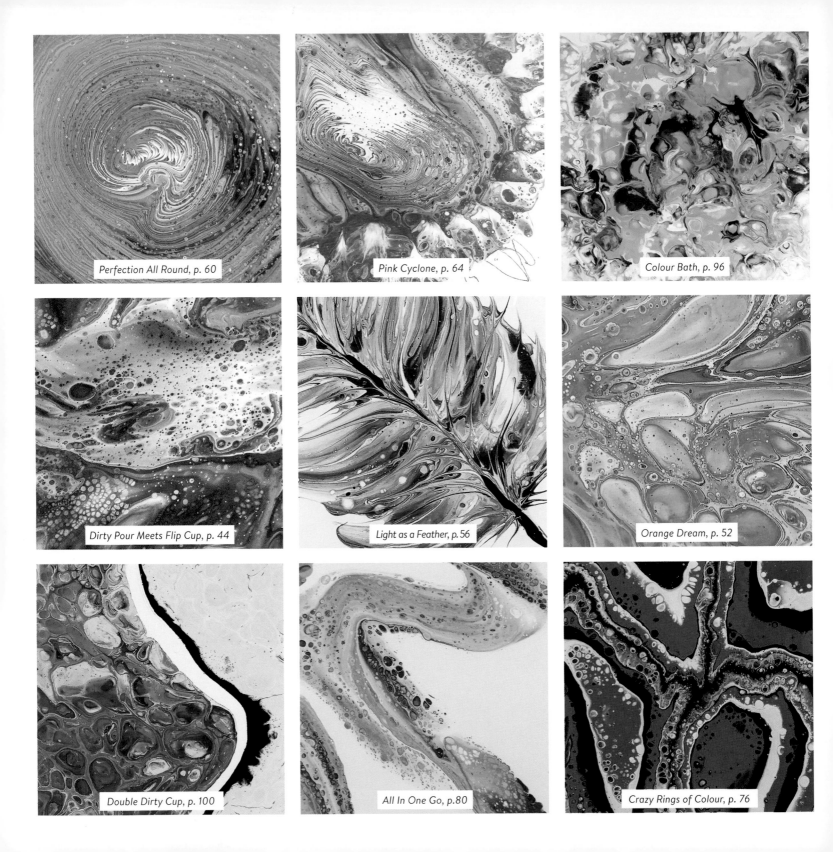

Perfection All Round, p. 60

Pink Cyclone, p. 64

Colour Bath, p. 96

Dirty Pour Meets Flip Cup, p. 44

Light as a Feather, p. 56

Orange Dream, p. 52

Double Dirty Cup, p. 100

All In One Go, p.80

Crazy Rings of Colour, p. 76

CONTENTS

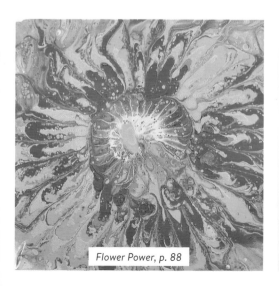

Flower Power, p. 88

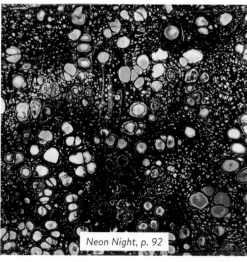

Neon Night, p. 92

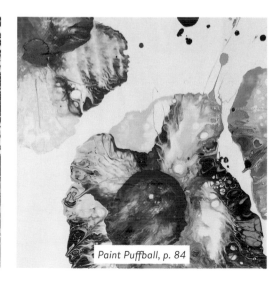

Paint Puffball, p. 84

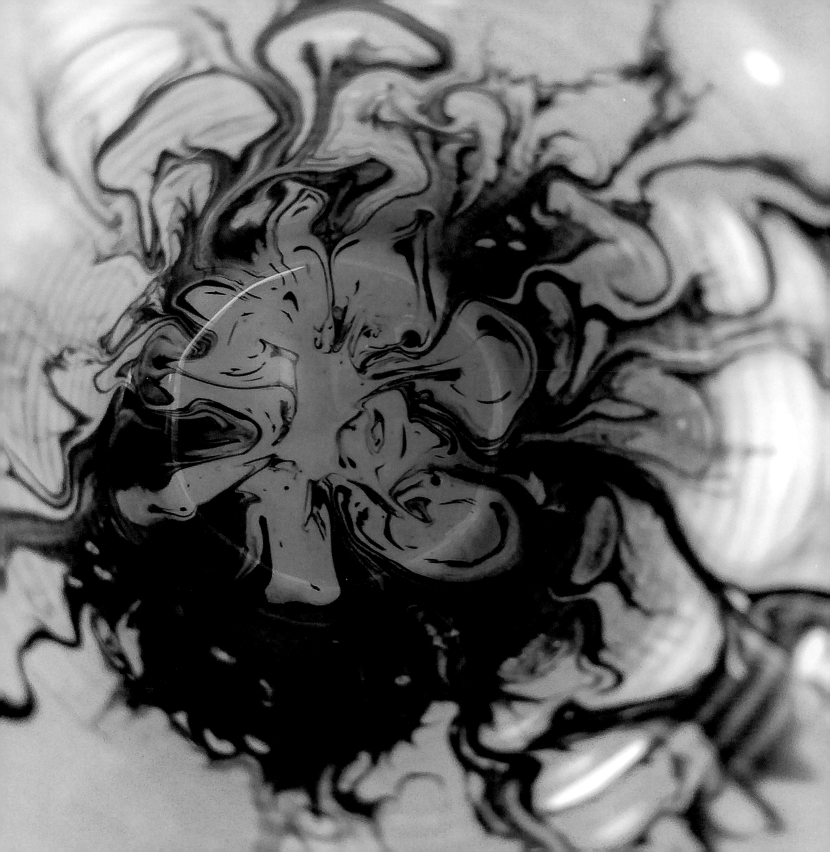

INTRODUCTION

Dear pouring fans and would-be fans, welcome to the experimental world of acrylic paint pouring! By mixing different elements and discovering their unpredictable reactions, you get amazing, unique results. You will also rediscover your own creativity.

I love trying out new things and getting stuck into current trends. This is how I came across pouring, which is as varied as it is unpredictable, and always throws up creative surprises. With its colourful interactions and variety of design techniques, acrylic pouring inspires everyone, not just experienced artists.

Pouring is an abstract art. The effects are created through the shapes, interactions and depths of colour. This book will provide you with lots of tips and practical advice about the materials, colour combinations and different techniques involved. Once you have mastered the basics, your imagination should know no bounds! My aim is to show you as many pouring techniques as possible, which you can follow step by step. You do not have to stick to the colour choices that I have made in this book. Choose colour combinations to satisfy your personal tastes and feel free to experiment!

This book is suitable for beginners as well as for advanced pourers, who will certainly find new ideas and inspiration in its pages. Take time to experiment and don't be put off if it doesn't work out perfectly each time. Keep going and allow yourself to enjoy the element of surprise!

I wish you lots of fun and a good dose of experimental joy in taking on the projects.

Best colourful wishes,

Tanja Jung

As well as acrylic paints, various other materials are used in acrylic pouring. Get to know about their qualities and how you can use them in this chapter – and put this knowledge to good use to maximize the success of your acrylic artworks.

Materials

THE WORLD OF ACRYLIC PAINTS

Working with acrylic paints is flexible and uncomplicated. The paints are water-soluble and almost odourless and the brushes are easy to clean in water; plus acrylic paints will adhere to almost any surface.

Qualities

You can find information about the qualities of any paint from the labelling on the packaging. Acrylic paints can generally be split up into two categories: 'Student grade' and 'Artist quality'.

The transition between these two categories is often blurred. As a result of ongoing research and development, you can now find very good student grade paints. At the same time, paints work according to the principle that you get what you pay for! If there is no indication on the label that it is the best or Artist quality paint, then it is generally Student grade paint.

Artist quality

These paints are marked as 'Professional' or 'Artist quality' paints. For this quality, the most expensive pigments are used in the highest possible concentrations to produce very adhesive and extremely rich paints. These paints are characterized by a high viscosity, while being easy to apply. For example, a 60ml (2 fl oz) tube of the best Artist quality paint contains more pigment than a whole tin of wall paint.

Student grade

Cheaper pigments are processed in lower concentrations to produce Student grade paints. The concentration of pigments varies from range to range. Well-known manufacturers usually offer several paint lines to serve all price ranges.

In principle, you can stick to the following basic rule: the cheaper the paint, the lower the pigment ratio.

Tip

Cheap acrylic paints from discount shops are often bulked out using fillers and are of lower quality. It is better to use a product from a recognized manufacturer; the better pouring experience will always justify the difference in price.

Specific qualities

You can find the specific qualities of any particular shade from a range in the information on the label.

Opacity

Although acrylic paints are generally considered to be opaque, there are big differences: there are opaque as well as transparent shades in all colour tones. Look out for the 'Square' symbol, which indicates the degree of opacity.

Lightfastness

Due to UV radiation, sunlight has a degrading effect, which can cause visible colour changes or the bleaching of colours. The lightfastness of any paint is rated using the Blue Wool Scale, which indicates how individual colours bleach or fade differently under sunlight. The degree of lightfastness is indicated by the number of asterisks.

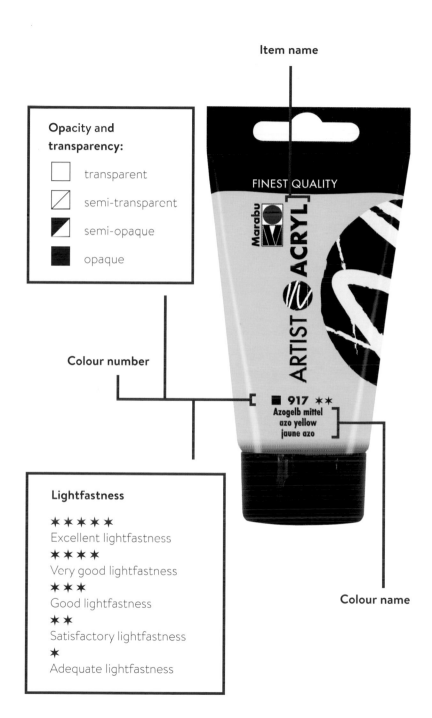

Item name

Opacity and transparency:

☐ transparent

◨ semi-transparent

◪ semi-opaque

■ opaque

Colour number

FINEST QUALITY

■ 917 ✳✳
Azogelb mittel
azo yellow
jaune azo

Colour name

Lightfastness

★ ★ ★ ★ ★
Excellent lightfastness
★ ★ ★ ★
Very good lightfastness
★ ★ ★
Good lightfastness
★ ★
Satisfactory lightfastness
★
Adequate lightfastness

MATERIALS FOR ACRYLIC POURING

Acrylic pouring is a fluid art in which diluted acrylic paint is poured onto a background, either directly or with an instrument, and where the colour gradations are changed by tilting the surface.

The variations in design that can be achieved in acrylic pouring come from the selection of paints, binders, oils and other ingredients (like glitter paste, for example) that can be mixed together.

Binding agents hold dry pigment together. In acrylic paints, these agents are called acrylic polymers.

Dimethicone is a form of silicone oil which is kind to the skin. That is often added to acrylic pictures to support the creation of cells (see right). When you pour paint, cells usually emerge in round or organic shapes and create a dynamic effect in the layers of paint.

Gel medium is a semi-solid material that can be mixed with acrylates to drastically change the texture and consistency (how thin or thick a paint is). Polymers of acrylic acid esters, usually referred to as polyacrylates, are used as binding agents for dyes and varnishes, injection moulding compounds and adhesives and in dentistry materials, among other things.

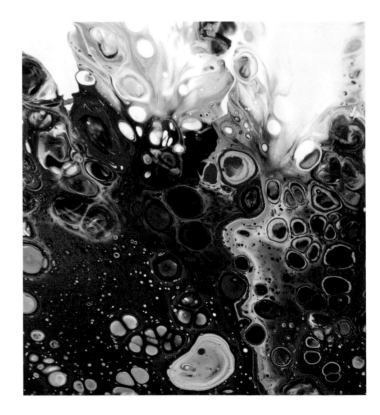

Gloss medium is a medium which you can add to acrylic paints to give them some shine or to varnish the surface. You can also use this medium in your pouring mixtures.

Pouring medium is an additive for acrylic paint which keeps the paint wet and workable for longer. As it binds the colour pigment, the flowing qualities are improved while still maintaining the paint's structure. You can buy pouring mediums such as Liquitex, Floetrol, GAC 800 or PVA glue from all good art suppliers.

Resin *(also epoxy resin)* is a synthetic resin used to seal pictures in order to increase the vibrancy of the colours and add depth to the picture. It produces a chemical reaction during mixing and hardens to a clear and impact-resistant plastic surface.

Silicone oil is added to the mixture of paint and medium in order to promote the formation of cells. When this oil is added, the top layer of paint opens up and the colours underneath become visible on the surface.

Varnish is a more or less transparent, film-forming liquid which dries into a hard, permanent coat and protects and enhances the surface of the picture.

Blowtorches There are two purposes for passing a heat stream (for example, using a catering blowtorch) quickly over the picture surface: firstly, air bubbles are removed from the paint and secondly, it promotes the creation of cells, as the silicone oil in the mixture is heated up and expands.

A few basic concepts

Intensity refers to the purity and brightness of a colour and is also called saturation.

Transparency and opacity – transparent paint is more or less see-through and lets the light pass through it. When applied on top of other layers of paint, the underlying colours partially show through and our eyes visually mix them with the upper transparent layer. A pigment which does not let light through is opaque.

Complementary colours are those colours which lie opposite each other on the colour wheel. When placed next to each other, they make the neighbouring colour appear brighter and more saturated.

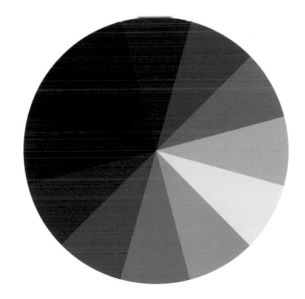

Paint density and cell formation

The **density** of the paint comprises the colour pigments as well as the binding agents and solvents. This results in different densities for different paints, which is relevant for acrylic pouring.

The denser the paint, the more likely it is to sink onto the painting surface, whereas paint with a lower density is more likely to rise to the top. This means that you have the ability to influence the **formation of cells**, at least partially, through the composition of your paints. White paint is generally very dense due to the pigments used. If this is poured at the same time as a green, which is less dense, the green will rise to the surface and will therefore be more prominent in the picture.

Note: when you pour dense paints onto less dense paints, (for example, white on green), the less dense paints will rise and the dense paints form the network structure of the cells, almost like an outline. In acrylic pouring terms, we call this a 'layer'. You can also use paint density for cell effects with the Swipe technique (see page 34).

Opacity when pouring

Along with its **density**, a paint's opacity is also an important factor when it comes your acrylic pouring pictures. Due to their individual qualities, the pigments used in individual acrylic paints produce transparent, semi-transparent or opaque colours. You can also increase the opacity by adding white.

Since opacity comes from the pigments and additives used, this can vary even within a single paint range. If the paint is good quality, the opacity is usually noted on the tube (see page 13). If this detail is missing, you can obtain further information from the manufacturer's website.

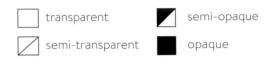

Colour selection and combinations

You will soon learn by experience which **colour combinations** you like. To begin with, it is best to choose at least one opaque colour, one semi-opaque colour and a transparent colour for your artwork. Then add further colours, so that you can see the effects of the different opacities.

The heavy, opaque paints are used for layers. This is the outline colour of the cells, in the middle of which the paint with a lower density can rise up.

Surfaces can be created which, due to the different opacities alone, will enable different artistic effects. The possible combinations here are almost unlimited.

Special liquid paints

Paints with a **more fluid consistency** can also be used in pouring. You just need to use a smaller amount of water for the desired pouring consistency. However, you should try to use a high-quality paint when using a more fluid variety; otherwise the brilliance of the colour will fade considerably. You can identify the more fluid paints as they usually have the terms **Fluid** or **Liquid** in the name of the product.

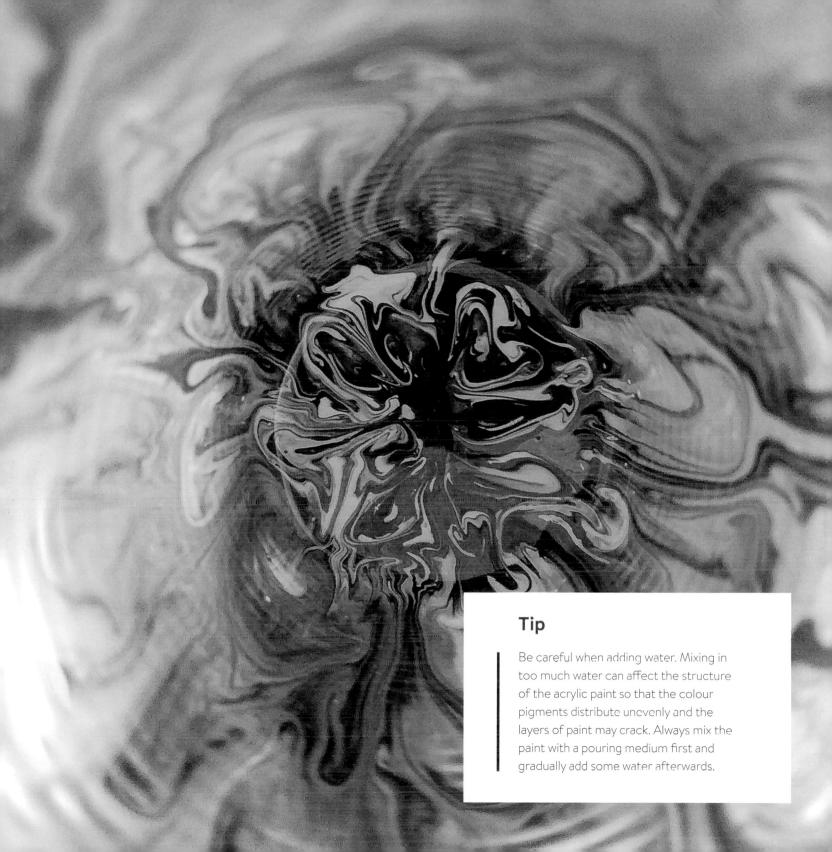

Tip

Be careful when adding water. Mixing in too much water can affect the structure of the acrylic paint so that the colour pigments distribute unevenly and the layers of paint may crack. Always mix the paint with a pouring medium first and gradually add some water afterwards.

Special effect paints

There are many acrylic-based effect paints on the market that you can use to add that certain something to your projects:

· **Metallic paints** give the finished pour a shimmering, metallic effect, which stands out from the other colours according to the incident light.

· **Iridescent paints** make the surface show different colours according to the angle from which it is viewed. **'Flip flop'** paints such as the multicoloured BERLIN FLIP FLOP from Marabu belong in this category, as they change colour according to the viewing angle and the incidence of light. The reflections and the changing effect work best on darker backgrounds.

· **Glitter paste** gives a fantastic glittery effect.

· **Neon paint** lights up under UV light (for example, Marabu's NEW YORK NEON fluorescent blacklight paint). The trendy neon colour shades work best on light backgrounds.

· **Pearl paints** produce a pearlescent effect and work best on darker backgrounds.

ADDITIONAL MATERIALS

There are several ways to mix your basic medium. You can mix it yourself inexpensively or buy it as a finished product. You can also draw on other materials that you have at home.

Vinyl and PVA glue

Vinyl and PVA glues are now available from many manufacturers at reasonable prices. The glue is mixed into the acrylic paint to bind the pigments. It can also be diluted easily with water.

Note: the high acidity content in the glue leaves the paint appearing matt and dull after drying. However, this can be corrected with a gloss medium or by varnishing the picture after drying.

Acrylic binder

You can also add acrylic binder to your pouring medium. It is available in either matt or gloss versions. The pure acrylic binder used in the production of acrylic paints and additives dries clear, is insoluble in water after drying, and has either a matt or a gloss effect.

Floetrol

Floetrol is a flow optimizer which was developed for the needs of painters. It improves the coating properties and the flow of water-based paints. Floetrol modifies water-based paints so that it is possible to work with them in a similar way to synthetic resin paints.

Floetrol increases the 'open time' and allows the paint to dry 'from bottom to top', which influences the drying time.

Floetrol maintains the high quality of the colour, in contrast with dilution with water. It does not affect the shade or gloss. Personally, I would always mix some into my medium, and many pouring artists will attest to its cell formation qualities.

Note: Floetrol has a strong smell and is certainly not completely non-toxic, so make sure your workspace is well ventilated.

Pouring medium

You obtain the necessary flow properties by using a pouring medium. Not only does it make the paint pleasantly smooth, it also binds with the individual pigments at the same time. Pouring medium improves the flow qualities without affecting the paint's structure. There are now various kinds available.

You can buy these mediums ready-made from, for example, Liquitex or Schmincke. These products are ready to use, of high quality and maintain the radiance of the colours. However, this is the most expensive option. If you create a lot of pictures and would like to save some money, you can make your own pouring medium.

DIY pouring medium

Mixing ratios (recipes)

There is no basic perfect recipe, but artists usually have their own favourites. There are various different combinations and possibilities for variation (manufacturer/quality/pouring medium and paint products), so you just have to suck it and see! I will give you some examples here to guide you. It is best if you test for yourself to see what appeals to you, and adjust as you prefer.

One more word in advance about the recipes: the quantities are not given exactly, just approximately – I do not measure or weigh materials. However, you should be especially careful when adding water: when you have reached the desired consistency, do not add more, as this can break up the pigments. For your first attempts, I recommend trying the following recipes:

Recipe 1:

- **40% PVA glue**
- **25% Floetrol**
- **20% acrylic paint**
- **Up to 15% water (until the desired consistency is reached)**

Add 2 or 3 drops of pure silicone oil to 100ml (3½ fl oz) of finished mixture (paint + Floetrol pouring medium) after mixing, and stir gently or thoroughly according to the desired size of the cells.

I use this mixture most of the time. Every now and then I add some gloss medium, but because I always varnish or use epoxy resin to finish my pictures, I do not usually need it.

Recipe 2:

- **70% Liquitex or Schmincke pouring medium (Floetrol for cells)**
- **30% acrylic paint**
- **Water if required (until the desired consistency is reached)**

Add 2 or 3 drops of pure silicone oil to 100ml (3½ fl oz) of finished mixture (paint + Floetrol pouring medium) after mixing, and stir each one gently or thoroughly according to the desired size of the cells.

Note: Schmincke advises that cracking may occur when silicone oil is added to the ready-made pouring medium.

Recipe 3: liquid paints
(see page 16)

- **40% high-grade liquid acrylic paint**

- **60% Floetrol or Liquitex pouring medium**

- **Water if required**

Add 2 or 3 drops of pure silicone oil to 100ml (3½ fl oz) of finished mixture (paint + Floetrol pouring medium, if cells are desired) after mixing.

Ready-made pouring mediums already contain a gloss medium. When you are mixing your own medium, you can add gloss medium to it. There are many manufacturers and it can be found in art shops.

You should leave enough time for the mixing of individual colours. I mix high-quality artist paint with pouring medium in a plastic cup with a wooden spatula for 1–2 minutes at a time, and it is worth the wait to ensure that the medium binds well with the pigments and water.

Silicone oil

Silicone oil is a clear, colourless, non-toxic, neutral, odourless chemical substance. Various oils can be used, for example Ballistol, WD-40 or hair oil. I usually use Ballistol as this is a particularly high-quality oil. A few drops of this are enough.

Stirring silicone – techniques and effects

After the pouring medium has been mixed well with the chosen colour in a container, you can add (according to the amount of paint in each) around 1–3 drops of pure silicone oil or 3 squirts from an appropriate spray bottle onto the surface of each of the colours.

The silicone can be stirred in with a wooden spatula in the next step:

If you want large cells, the wooden spatula should be slowly drawn through the paint once or twice only, so that the silicone does not mix in too well with the paint.

If you want lots of little cells, then the silicone oil should be mixed with the paint more intensively, by stirring for longer with the spatula.

You can also choose which colours should form cells (which ones to add silicone to) and which colours should not form cells. I add some silicone to most colours apart from black or white. However, this too is just a matter of taste.

Catering blowtorch

The catering or kitchen blowtorch is filled with lighter gas. In acrylic pouring, it has two functions: first, the air bubbles created during stirring can be removed; second, the silicone oil added to the paint will be heated up. This causes it to expand and rise to the surface – which, in turn, contributes to the formation of cells.

The blowtorch should be used with extreme caution, as the paint can easily be destroyed or burnt by the heat. Always keep a safe distance away and move the blowtorch gently back and forth. Now and then, wait for a short while to give the silicone the opportunity to rise up and displace the other colours for the cells. This process always takes a little time and the cells grow according to the heat effects. Work with rapid but careful movements.

Cloths/towels

It is sensible to have some towels (for example, kitchen towels) or cloths to hand during the pouring process, so that you can clean paint off your hands, gloves, or the work surface, when required.

Pipette for oil

In order to measure the oil accurately or in drops, it is best to use a pipette. If you want to use a spray oil, you can first spray it into a container and then use the pipette to remove the oil for use with the paints.

Bottles with nozzles for water and paint

In my experience, a bottle with a nozzle is easier to control and more practical when adding a precise amount of water to the paint. There are also some techniques where an exact application of paint through the nozzle on a bottle is useful.

Bottles with screw tops

I use these for larger quantities of white and black paint and also for my pouring medium, which I like to mix up in advance.

Funnel

Funnels are useful for filling the individual mixtures into suitable containers.

Cups

You can buy plastic cups, which are available cheaply in large packs. Used (and subsequently cleaned) yoghurt pots or similar also work really well.

Tarpaulin/cardboard

You need a tarpaulin, a cover sheet or a large piece of cardboard or similar to protect your work surface.

If I am pouring several pictures, I also like to use thin brown wrapping paper. In these cases, I usually put a pile of sheets of this paper on my work surface and, after the completion of a piece, I remove the top two sheets. By doing this, I have a fresh, clean workspace straight away.

Hairdryer/straws

A hairdryer or straws are required for the Air Swipe technique, which will be mentioned later (see page 86).

Combs/plastic forks

Combs or a plastic fork can be used to add further designs to the image. You can use them to simply drag different colours across the picture.

Sieve/sink strainer/juice extractor

You can achieve various patterns in your pouring using different kinds of strainer.

Wooden spatula

You need a wooden spatula to mix the paint with the medium. You can find these in various places including pharmacies.

Long palette knife/squeegee

You can use a palette knife or squeegee to spread the medium onto the background. These are also used in the Swipe technique.

Wool

You need wool or a shoelace for the String technique.

Drawing pins

These act as separators for canvases. They can be pressed or knocked into the back of the frame.

Tip

Any paint leftovers should not be disposed of down the sink, as paint can clog the drainage pipes very quickly.

AFTER POURING

Enhance your picture to give it a more sophisticated appearance. Using varnish, resin or epoxy resin will make the colours appear more vibrant. Find a suitable frame for the finishing touch.

When you have poured your picture using your preferred paints and techniques, there are still a few more steps that you should carry out. First, it is essential to allow for a specific drying time. In addition, you should remove any silicone residues from your picture and then protect and enhance it using varnish or resin.

Drying

It can take between three and five days for your artwork to dry sufficiently and set so that it can be worked on again, depending on the thickness of the paint application, the pouring medium and the temperature and humidity.

However, it is advisable to wait at least one to two weeks more for the picture to dry completely before varnish or resin is applied to finish off the picture. For larger pictures, paint can collect in the middle of the picture as the canvas sometimes sags.

The formation of unwanted cracks on the surface, which you often read about in relation to acrylic pouring and which I can also tell you a couple of stories about, can come about for three reasons:

The paint was too thick: You must take care that the medium- and paint mixture to be poured is not too viscous. The consistency needs to resemble liquid honey or a thin pancake mixture; if it is thicker, the mixture needs to be thinned with some additional water.

Drying too quickly: There is a significant risk of cracking if your picture dries too quickly. It is therefore worth ensuring that the picture is not left in direct sunlight and that the room temperature is not too high, so that the water in the picture does not evaporate too quickly.

It's in the mix: Now and again, the medium and the silicone oil do not combine well. The instructions on the pouring medium from Schmincke, for example, advise caution when using it with oil to avoid the formation of cracks.

Why should you seal your picture?

When a colourful poured picture has dried thoroughly, the colours can often appear dull. This is as much to do with the water added to the paint, which can split the pigments apart, as with the acid content of the glue. Using varnish or resin will enhance and restore the original intensity of the colours. In addition, the varnish or resin will smooth the surface of the picture. The picture gains more depth of colour, the paints appear more vibrant and richer, and the detail of the cells and colour gradations is sharper.

Maintaining vibrancy: The lightfastness of acrylic paint will vary according to the quality of the colour pigment. If your pictures are going to be exposed to direct sunlight for a long period of time, they will start to fade unless you seal them.

Uniform gloss: Individual areas will dry differently according to the acrylic paint and pouring medium used. This can be evened out with a varnish or resin. Additionally, the picture can be given the desired effect – matt, silk or gloss.

Preparations for sealing

Before you can cover your artwork with one or more protective layers, the top surface must always be thoroughly cleaned so that the varnish or resin adheres to the surface and an even application is possible.

Particularly where silicone oil has been used, the surface must be cleaned of any oil residue. To achieve this, spread some cornflour across the picture and rub it in. Make sure you also work on the sides of the painting surface. After it has been left for approximately 12 hours, the cornflour can be removed with a damp cloth and a little washing-up liquid. Next you

should carefully wipe the picture dry and then leave it to air dry. Because acrylic paint is water-resistant when dry, nothing will damage the picture from now on. Now your artwork is ready for the finishing touches.

How do I seal my pictures?

Basically, there are two ways to apply a seal to your pictures:

Varnish/lacquer

This is the simplest and most popular way to protect pictures. Varnish can be applied simply with a brush or spray can. If you want to apply the varnish with a brush, you can thin it out first with a little water to spread it more easily across the picture, and the brushstrokes will not be seen after it has dried. It is important to repeat this process two to three times to achieve a good protective effect. When choosing the varnish, make sure that it contains a UV filter, so that the picture does not turn yellow.

Resin

You need epoxy resin to seal your pictures. This consists of synthetic resin and a hardener. These two components are mixed together in a certain ratio (shown on the packaging), poured onto the surface and then spread with a spatula or similar. You can also work out the required amount for yourself: it should be around 300–400g per square metre (9–11oz per square yard).

This type of finish is more elaborate and more challenging than varnish, but it does produce a good-quality, high-gloss

Basics

surface. The picture almost looks as though it is behind glass. Make sure you buy a high-quality epoxy resin to protect your pictures from yellowing.

In the event of air bubbles forming, wait for a short while to see if the bubbles pop by themselves. You can help this process along, carefully using a spatula or a toothpick. Air bubbles also disappear very easily if you use a kitchen blowtorch. Remember to hold it a safe distance away from the surface and always make rapid movements.

The drying time for resin is only a few hours.

Note: Never work without gloves!

Tip

To keep the edges clean, you can mask them in advance with some adhesive tape. Fix the tape around the edges of the canvas and let it stand a few millimetres proud. This way, the resin will remain on the picture instead of sliding down the edge.

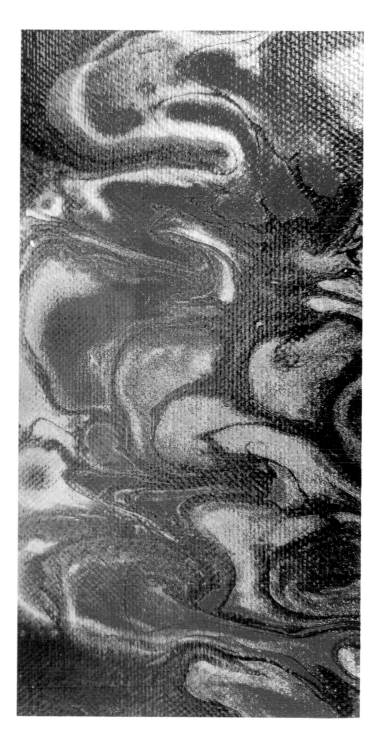

SURFACES FOR ACRYLIC POURING

The main thing is that the painting surface should be as firm as possible. In addition, it should not saturate too quickly as the paint and medium mixture contains a lot of water.

The most common surface for pouring is **canvas on a stretcher frame** in various shapes. Triangular and circular versions are available as well as rectangular.

For your first attempts, you can save a little bit on the quality you buy. However, the very inexpensive canvases often warp and the tension is not the best either. This will become a problem when your design literally 'runs away' from you. Because it takes some time for the pouring to dry, a beautifully poured painting can look completely different at the end, because the base was not level or the paint has run too much towards the middle.

Tiles are also popular as a surface for acrylic pouring, particularly in the USA.

MDF boards are also well suited to acrylic paint pouring. Medium-density fibreboard is a wood-based fibreboard material, which can be cut into any shape you like beforehand with a jigsaw.

Painting boards are made from HDF (high-density fibreboard). These are compressed in a special drying process by soaking in glue and heating under pressure. Boards covered with canvas are also available.

Another very interesting base material to try is **glass** or **plexiglass**. If a sheet of glass with a poured work on it is placed in a frame and then lit from behind, it creates really fascinating effects.

Other completely different types of surface can also be very interesting – something like an old vase, a plant pot or a tray, which can be turned upside down before pouring.

Painting and pouring backgrounds
to try:

- Canvas/Stretcher frames
- Tiles
- MDF boards
- Glass/Plexiglass
- Wood

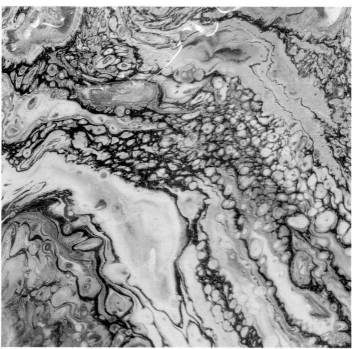

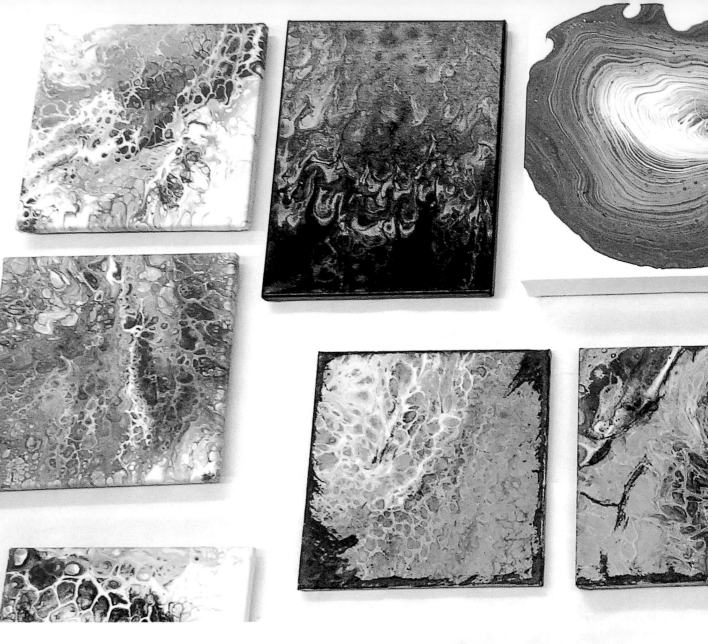

Let yourself be inspired by the variety
of techniques available. When it comes to
colour combinations, there are
practically no limits.

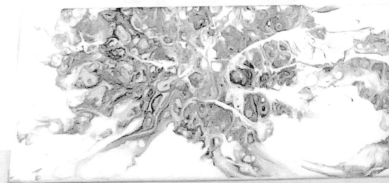

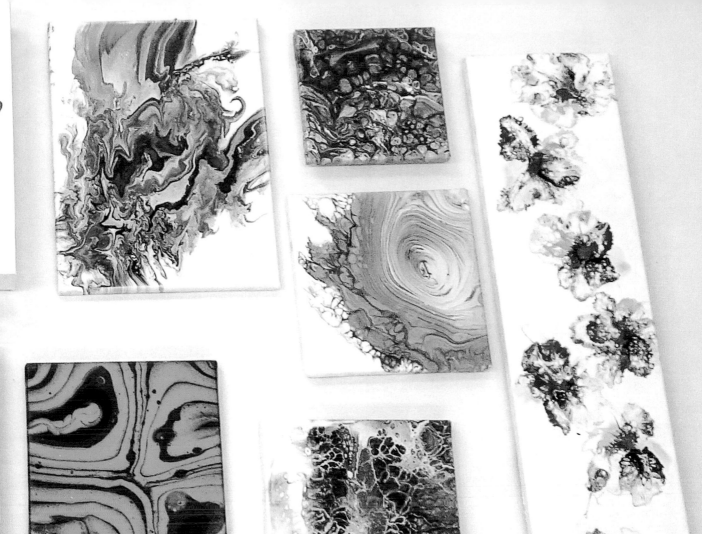

How to start

TECHNIQUES

There are many and varied pouring techniques, and more will almost certainly have popped up while this book was being produced! Those presented here are a selection of the techniques which I have tried out for myself.

Dirty Pour

For me, the Dirty Pour is one of the basic techniques and several methods and variations can be derived from it.

In this technique, the paint mixtures are poured one after another into an empty cup. The paints can be mixed with silicone in advance as desired (1–3 drops per colour). The paint mixtures are either added to the cup slowly, one after another, or poured from a great height which, to a greater or lesser extent, serves to mix the paints together. When the cup is full, the paints can be mixed lightly again with a wooden spatula. Just draw the wooden spatula once or twice in a cross shape through the paints.

The paint mixture is then poured across the canvas in wavy lines. After pouring, go over the picture quickly with a kitchen blowtorch from a distance of around 15–20cm (6–8in) to let the air bubbles escape and to activate the first cells. Then you need to disperse the paint mixture over the picture by tilting the painting surface carefully back and forth. Make sure that the edges are also covered with paint.

Flip Cup

Flip Cup is also a form of Dirty Pour. The paint mixtures are poured together into the cup (see Dirty Pour). The cup is then flipped over onto the canvas in one movement, or the canvas is placed onto the underside of the cup and then both are flipped over at the same time without any of the paint seeping out. After a short time, when the paint has sunk to the bottom, the cup is removed to the side so that the paint runs.

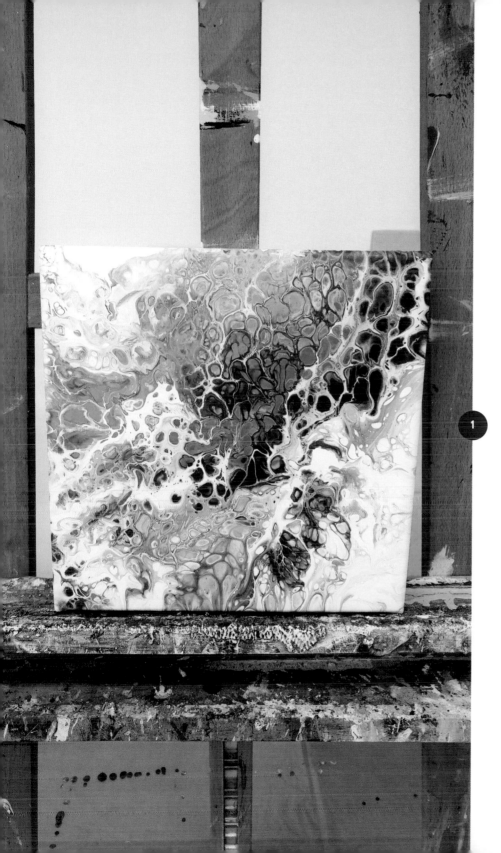

Tip

Instead of just one cup with various mixed paints, you can also flip several cups with different mixed paints upside down onto the canvas. The only problem comes in flipping over the other cups onto the canvas without the paint spraying. To achieve this, the cups should not be filled to the top.

Afterwards, with a wooden spatula, use the paint which drops or drains off the edge when tilting the frame to fill in any small dots or areas around the rim of the canvas that are still without paint, using the same colour.

Swipe technique

The Swipe technique is a wiping technique. You can use Dirty Pour as a basis for this.

The wiping of the paint takes place at the end of the pouring using, for example, a palette knife, some thick food wrap or a tea towel. By wiping the selected layer of paint, you can create flowing movements, and cells crystallize better.

For this technique, each colour should have a few drops of silicone oil added before it is poured. The silicone oil ensures that the top layers will open up so that the brilliance of the colours in the layers underneath become visible.

The Swipe technique usually involves a further colour (often white or black, as these are good for creating a net structure on the top layer) being poured rather more thickly onto the edge of the canvas and then, with one of the tools mentioned, being drawn across the other paints.

Using the tool means that the opaque paint (for example, white or black) is wiped very thinly over the other paints, so that this opaque paint only covers the other paints relatively thinly and then slowly sinks downwards.

The underlying paint layers with silicone mixed in quickly push themselves to the surface, and so reveal the colours below. Cells are also formed.

Double Swipe

In Double Swipe, the paint at the edge is drawn in both directions, once to the right and back again to the left. In the process the paint on top becomes thinner, more cells emerge and the paint rises more effectively to the surface.

Puddle Pour

Puddle Pouring is a technique whereby acrylic paints are layered on top of each other in 'puddles' before the canvas is tilted. This creates interesting designs in flowing colours. The first paint poured onto the canvas forms the background onto which further paints are poured and mixed.

Swirl/Tree Rings

No silicone is used in the Swirl technique (also called Tree Rings because they look like the rings visible in cut tree trunks). One paint is selected as a background colour. This will mostly be displaced later by the main colour. **The individual colours are mixed in individual cups as in the other techniques and then, as in the Dirty Pour technique, poured into a combined cup. Be careful that the paints do not mix in with each other.** In this technique, choose a point in the middle of the picture and pour the paint slowly, in small circular movements (from the shoulder, not the wrist) into the middle of the puddle being formed. After pouring, the patterns can be lightly and gently spread over the canvas. Wonderful effects can be created if you tilt the canvas during pouring.

String technique

You could also describe the string technique as the Thread or Cord technique. Several cut pieces of thread, string, strands of wool or chains are dipped into cups filled with paint and then pulled through the pouring. The strings can also be placed onto the base coat first, and then pulled through it. The paints are mixed in advance with silicone oil. Interesting colour effects are created by pulling the strings soaked in acrylic paint. This technique works beautifully when the background is in just one colour and it creates a stark contrast with the applied paint.

Dipping

In this technique, the surface, for example the canvas, is dipped into the mixed paint. Interesting designs and cells can be created in this way.

You can pour your pattern onto a piece of foil or baking paper. This surface should be as water-resistant as possible so that the paint is not absorbed. Then lay a canvas on top of this to create an impression of it.

This technique can also be used if paint flows over the edges when pouring another picture. The excess paint is simply lifted off onto another (or the same) canvas.

You can also make matching pictures with the Dipping technique. To do this, firstly a pattern needs to be poured onto a canvas. Then a reflected image is made of this picture by taking a fresh canvas and pressing it onto the previously poured canvas.

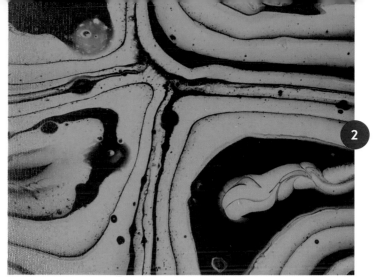

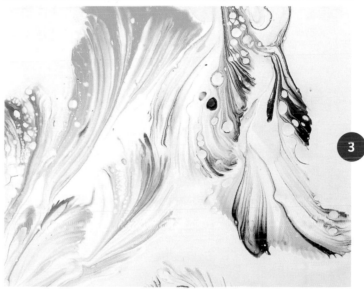

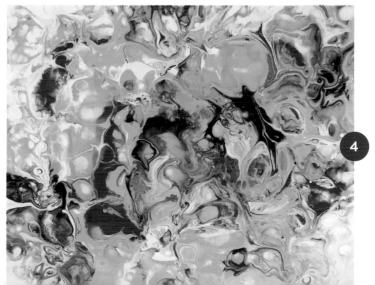

MIXING THE PAINTS

"When we take time, time gives back to us," said the author, Ernst Ferstl. Take your time mixing the paints and your picture will turn out well!

Every paint that you want to use for your picture must first be mixed with pouring medium. How much paint you need will vary according to the size and technique used in each of your pictures. For every poured picture, you need paint, pouring medium and water.

For a picture measuring 24 x 30cm (9½ x 11¾in), you should prepare the following mixture:

> **For three colours, you need:**
>
> - ⅕ cup PVA glue
> - ⅒ cup Floetrol
> - ⅒ cup paint
> - Up to ⅕ cup water

You will soon discover for yourself the quantities you require for each picture size. It always depends on how many different paints you use for a particular picture.

First pour the glue and the Floetrol in the cup and mix them together. The next step is to add the paint.

Stir this mixture very gently and not too quickly. The faster you stir, the more air bubbles will be created. Next, carefully add some water to dilute the mixture and stir it until the paint has completely blended in. Repeat this process as often as required until the desired consistency is reached. The paint should run, not drip, off the wooden spatula.

Only when the paint has reached the perfect consistency, add 1–2 drops of silicone oil to each cup and stir the mixture. Remember, the more colours you use in your picture, the less medium and paint mixture you will need to stir in to each cup.

At the end, if you are using a Dirty Pour technique, the result will be a well-filled cup of pouring and paint mixture.

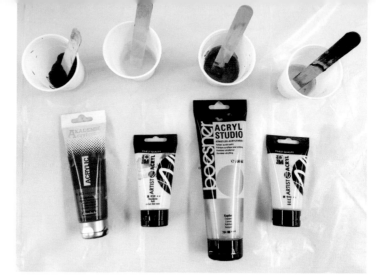

Tip

If the paint has been left standing for a long time, it can thicken. Test the consistency of the colour again just before you pour and, if necessary, add a drop more water.

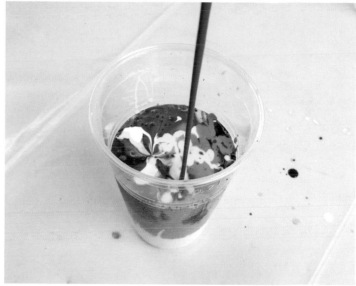

The larger the canvas, the more paint you will naturally require. Any paint left over after a project can be stored in sealed containers and used for other projects.

It is a good idea to mix a larger quantity of white and pouring medium, as this is often used as a base coat. The same is true for black, if you want to use this more often as a base.

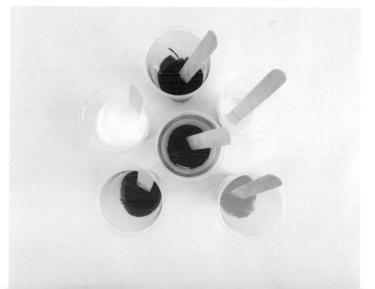

SETTING UP THE WORKSPACE

A well-prepared workspace will make your work much easier and your pouring much more enjoyable.

The preparation of the workspace and setting out the required materials is especially important in acrylic pouring.

As the medium and paint mixture will be poured over the frame and will run quickly over the sides, I recommend that you take the following precautions:

A thin tarpaulin is ideal, or perhaps some painter's masking film, and on top of this, a large piece of cardboard that can be disposed of at the end of the work. Thin packing paper is also suitable. I often lay several layers on top of each other. After finishing a picture, I remove the top two sheets so that I can immediately continue with the next picture. For smaller pictures you can also use a flat cardboard box.

Because pouring involves lots of paint and medium, disposable gloves are also highly recommended. I put these on straight after I have set out my materials.

Before starting the project, set out the number of cups that you will need for the colours – plus one more cup if, for example, you want to do a Dirty Pour. Also, have the wooden spatula to hand; this can be wiped after use and used again.

It is also important to have some kitchen paper, disposable wipes or an old cloth in place so that your hands or gloves and your work materials can be cleaned occasionally. When using kitchen paper, I always tear a few sheets off in advance and keep them handy. A bucket of warm water with some washing-up liquid can also be very useful.

Fill a bottle with a nozzle with water. You might even have some distilled water to hand. As this contains no lime or other residues, it can only affect your picture in a positive way.

In addition, lay out or prepare all the paints that you need for your planned picture.

Personally, I always mix a large quantity of pouring medium with white in advance. You can find the recipe on page 20.

As already mentioned, paint will also drip from the edge of the picture. So that the picture does not get stuck to the base as it dries, I press or knock some drawing pins into the frame on the back of the canvas, to act as spacers.

Place all of your additional materials nearby, so that you have easy access to them for the particular technique that you are going to be using.

A spirit level is also important. Use it before pouring to check that the base is level and that the picture is level on it. You can use the pins which were pressed into the back of the frame to even out any height differences. This is important so that your picture does not 'run away' after pouring!

To collect the paint residues, screw-top jars are useful. The leftover paints can be stored in these until their next use. Of course, each paint goes in a separate jar.

Materials:

- Various acrylic paints (white is important)

- Floetrol and PVA glue

- Canvases or other painting surfaces (MDF boards for example)

- Silicone oil (recommended: Ballistol)

- Water in a small bottle with a nozzle; several bottles as required

- Plastic cups or old yoghurt pots

- Small catering blowtorch

- Wooden spatula for stirring (available from pharmacies)

- Disposable gloves

- Paper towels

- Small spirit level

- Drinking straws

- Old newspapers or other material to protect the workspace

- An old sieve, some wool or string as appropriate

- Drawing pins as supports for the canvas

Wear old clothes or protect your clothes with an apron or overalls.

Find your favourite technique.
There are three levels of difficulty:

1 = simple

2 = medium

3 = advanced

Projects

DIRTY POUR

We will start our pouring adventure with five colours at once and the Dirty Pour technique. A dynamic, vibrant picture with an exciting white contrast should emerge.

Projects

Painting surface

Canvas 24 x 30cm
(9½ x 11¾in)

Paints

Up to ⅕ cup of each colour

Primary yellow
Red orange
Cadmium red medium
Light green
Ultramarine blue
White

Other materials

DIY pouring medium
Silicone oil
7 cups (6 colours and 1 mixing cup)
6 spatulas
Long palette knife or squeegee
Blowtorch

Water
Gloves
Paper towels
4 drawing pins (spacers)
Spirit level if required

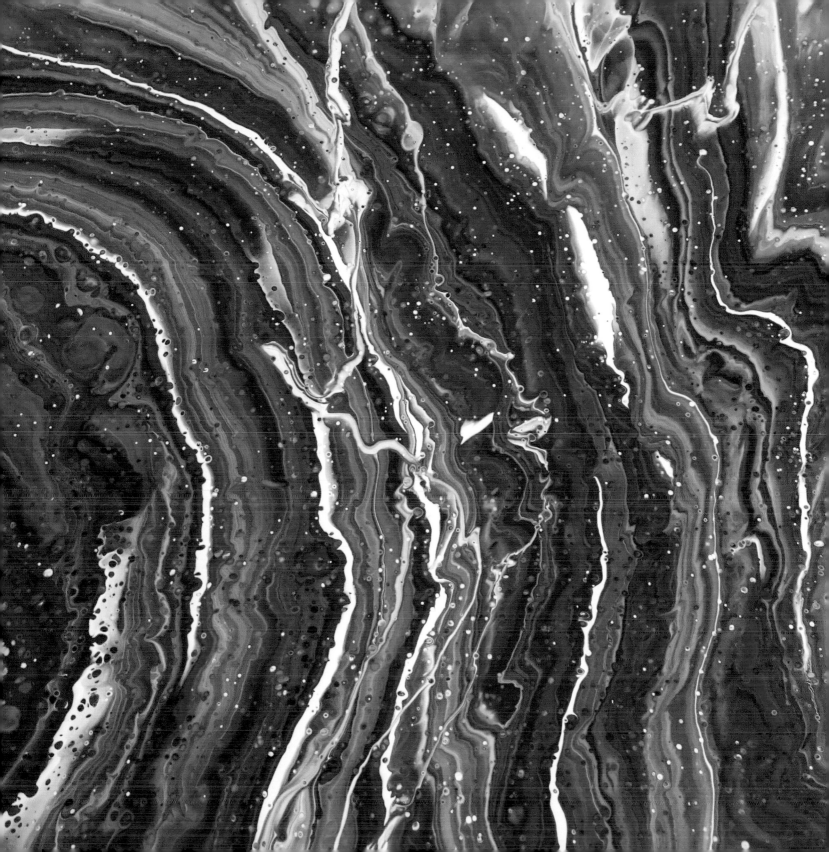

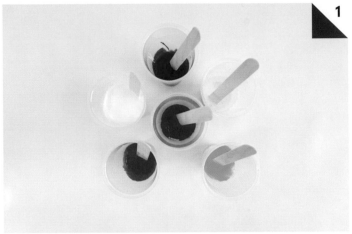

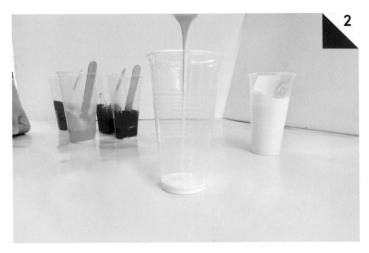

On the prepared workspace, mix the colours with pouring medium and silicone oil in individual cups. Use the spatulas to stir. The white mixture **does not contain** silicone oil at this point.

Starting with some white, pour the colours into the mixing cup one after another. Stir the mixture around slowly with the spatula. Using your hands or a palette knife, prime the canvas and the side edges with lots of white.

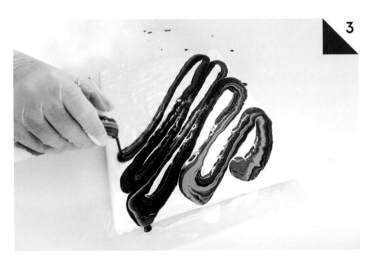

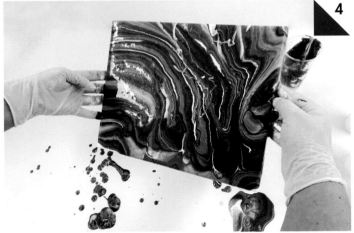

The pouring begins! Pour out the colours from the mixing cup in wavy lines over the primed canvas.

Remove the air bubbles with a blowtorch by moving the flame quickly back and forth over the picture from a distance of 15–20cm (6–8in). Now take the picture in both hands and spread the colours out as desired by changing the angle.

Make sure that the paint also runs over the side edges of the picture. Take a strip of cardboard, bend it in the middle and run it around the edge of your picture. By doing this you ensure that the paint runs specifically towards the edge of the picture, and not just freely downwards. Fill any empty spaces with paint which has run from the picture using a wooden spatula.

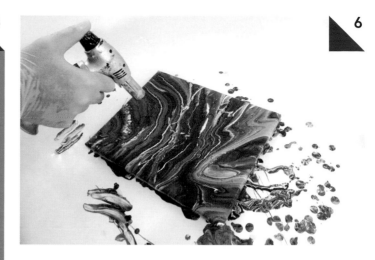

When you are satisfied with the colour gradations, apply the blowtorch once again over the picture, with the flame about 15–20cm (6–8in) away, in order to remove any remaining air bubbles and to activate the silicone oil.

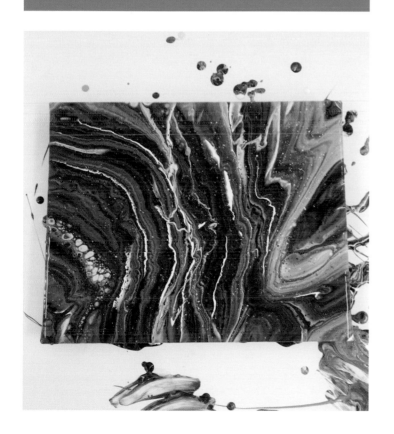

To dry the picture, lay it flat on a level surface. It will take 3–5 days depending on the room temperature and air humidity. Check the surface with a spirit level, as if it is even at a slight angle, the colours will continue to run.

DIRTY POUR
MEETS FLIP CUP

In this project we combine the techniques of Dirty Pour and Flip Cup to make a simple but very effective pour!

Painting surface

Canvas 24 x 30cm
(9½ x 11¾in)

Paints

Up to ⅓ cup of each colour

Metallic taupe
Neon green
Red orange
White

Other materials

DIY pouring medium
Silicone oil
5 cups (3 colours, 1 white and
1 mixing cup)
4 spatulas
Long palette knife or squeegee
Blowtorch

Water
Gloves
Paper towels
4 drawing pins (spacers)
Spirit level

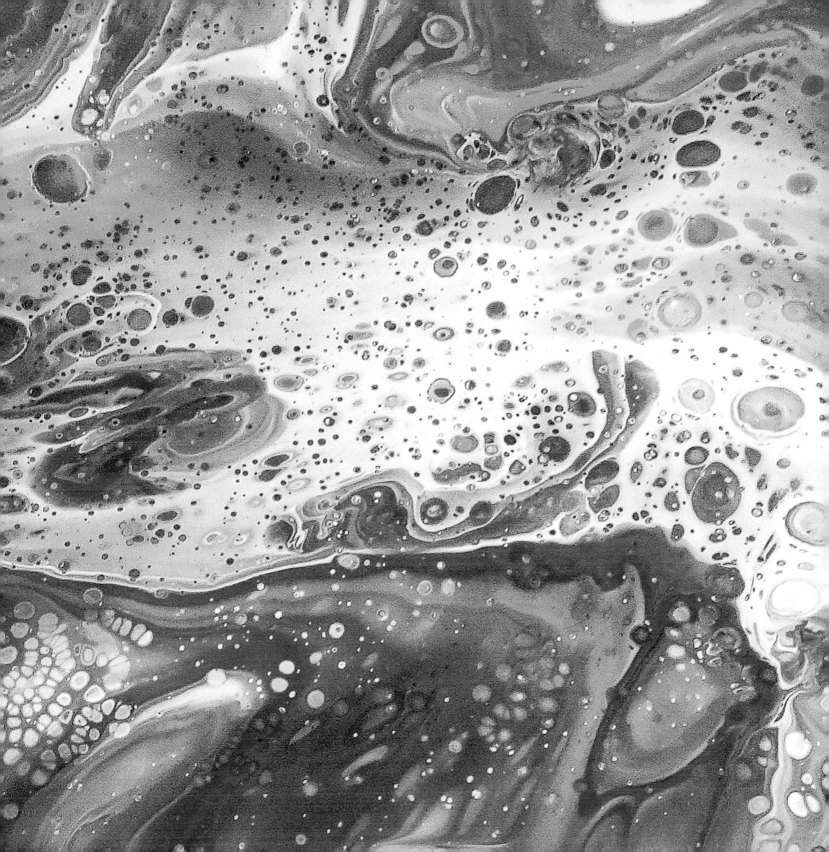

1

Prepare the paints in the individual cups with the pouring medium and add a few drops of silicone oil to each – apart from the white. Stir the silicone carefully and slowly into the paint to allow large cells to form later.

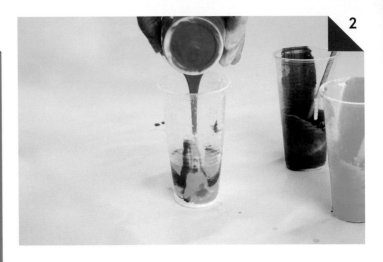

2

Starting with white, pour the paints slowly into the mixing cup and then stir the mixture carefully with the wooden spatula.

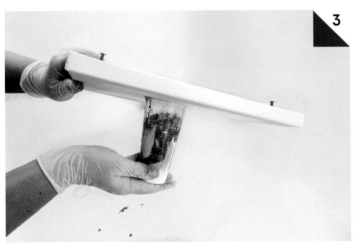

3

Take the mixing cup in one hand and place the centre of the canvas on top of it, like a lid. Now hold the cup and the canvas tightly together and turn them over – the flip! Now the cup is upside down on the canvas.

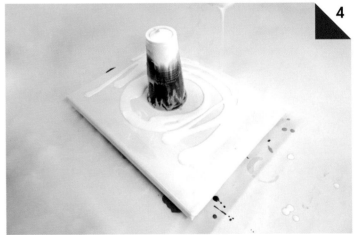

4

Let the cup stand for approximately 1 minute, so that the paints can flow downwards. In the meantime, with the palette knife or your hands, spread a coat of white around the cup to increase the flow of the paints across the canvas.

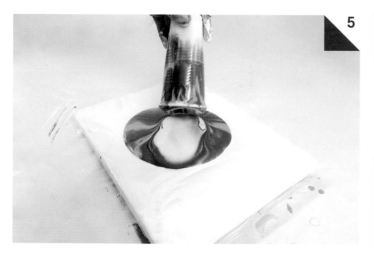

5

Now tilt the cup carefully and lift it slowly from the canvas. You can drip the paint that is left in the cup into the white areas around the big puddle.

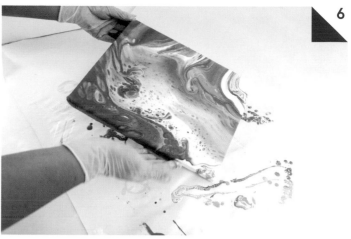

6

Using the blowtorch, remove the air bubbles by moving the flame quickly back and forth over the picture from a distance of 15–20cm (6–8in). Now take the picture in both hands and spread the paint out as desired by changing the angle.

7

Make sure that the paint also runs over the side edges of the picture. Fill in any blank areas using paint that has run off the picture and a wooden spatula. When you are satisfied with the colour gradations, put the picture down again and warm it up once more with the blowtorch to boost the cells.

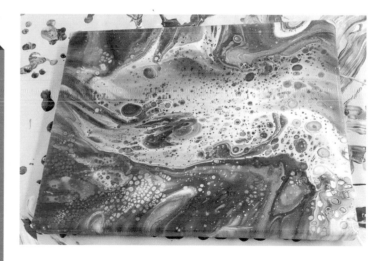

Now lay the picture flat on a level surface and leave it to dry for 3–5 days.

BLACK BEAUTY

With the Swipe technique, you can make colours shine! This works particularly well with black or white as a base colour.

Painting surface

Canvas 24 x 30cm
(9½ x 11¾in)

Paints

Up to ¼ cup of each colour

Cherry red
Ultramarine blue
Primary yellow
Light green

1 cup

Black

Other materials

DIY pouring medium
Silicone oil
5 cups (4 colours and 1 black)
5 spatulas
Long palette knife or wet paper towel
Blowtorch

Water
Gloves
Paper towels
4 drawing pins (spacers)
Spirit level

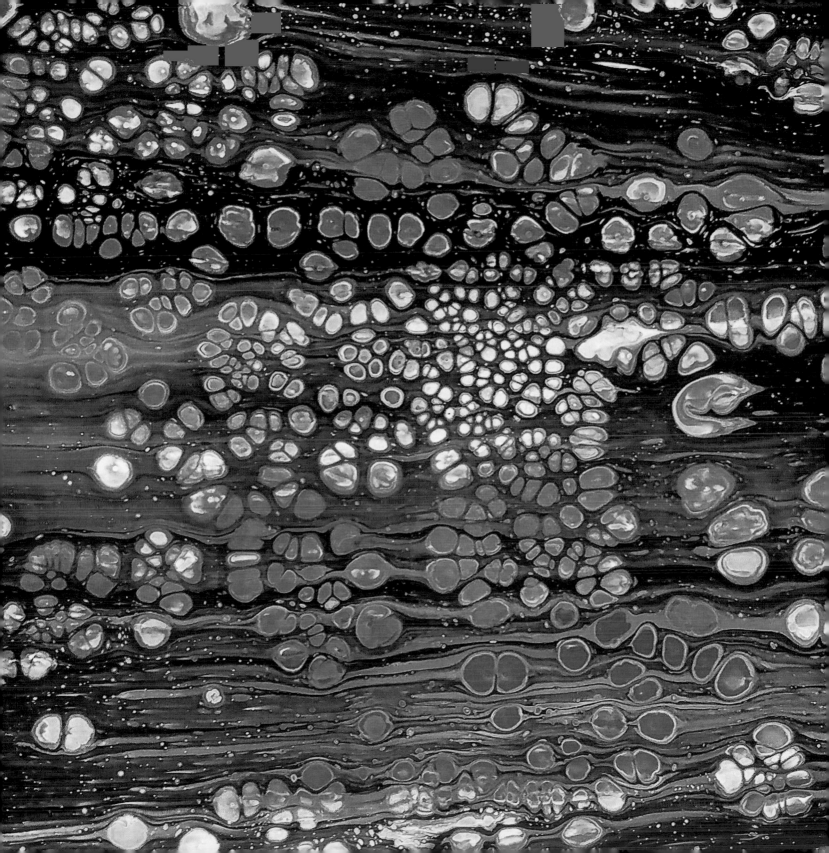

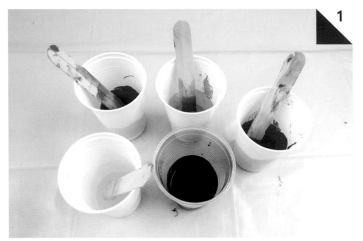

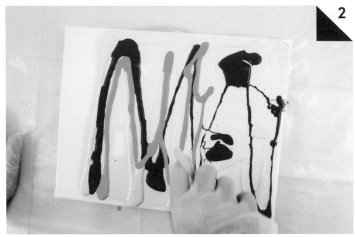

Put red, blue, yellow, green and black into cups and mix some pouring medium into each one. Then add a few drops of silicone oil into each colour (except black) and stir with the spatula. The cup with the black should be filled more generously.

Now pour all of the colours apart from the black out of the cups and onto the canvas in wavy lines, one after the other. When doing this, leave a few centimetres free on the left edge of the picture.

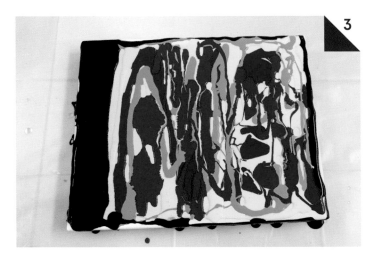

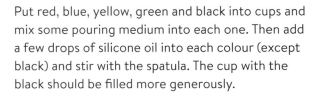

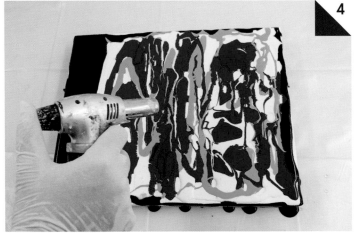

Now pour the black onto the free area on the left and around the edges of the picture.

With the blowtorch flame at a distance of 15–20cm (6–8in), remove the air bubbles.

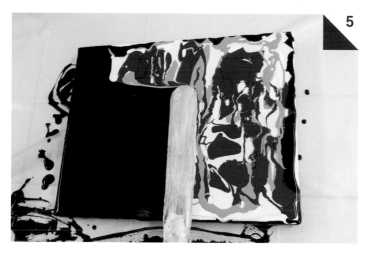

5

Take a long palette knife (or a wet paper towel) and place it in the black area on the left, then spread the black paint from the left to the right side of the picture.

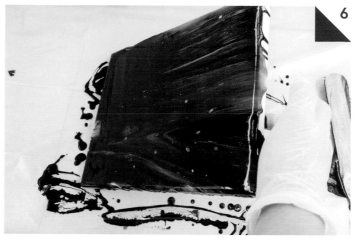

6

By lifting one side of the picture, you can bring some movement into the interplay of colour.

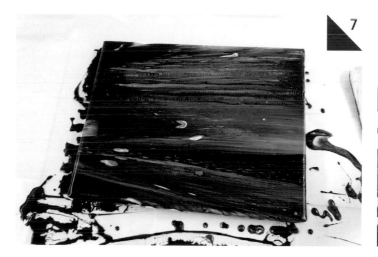

7

When you are satisfied with the colour gradations, take the blowtorch once again and activate the silicone oil.

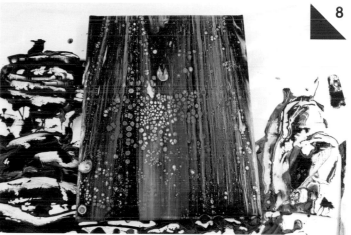

8

The combination of stripes and cells results in an exciting overall picture. As always, the picture should be dried on an absolutely level surface.

ORANGE DREAM

BIG CELLS

Dirty Pour and Flip Cup: Harmony instead of contrast is the theme for this project, but it is still a head-turner and the effect is far from ordinary!

Painting surface

Canvas 24 x 30cm
(9½ x 11¾in)

Paints

Up to ¼ cup of each colour

Van dyke brown
Primary yellow
Red orange
Orange

1 cup

White

Other materials

DIY pouring medium
Silicone oil
5 cups (4 colours and 1 white)
5 spatulas
Long palette knife or squeegee
Blowtorch

Water
Gloves
Paper towels
4 drawing pins (spacers)
Spirit level

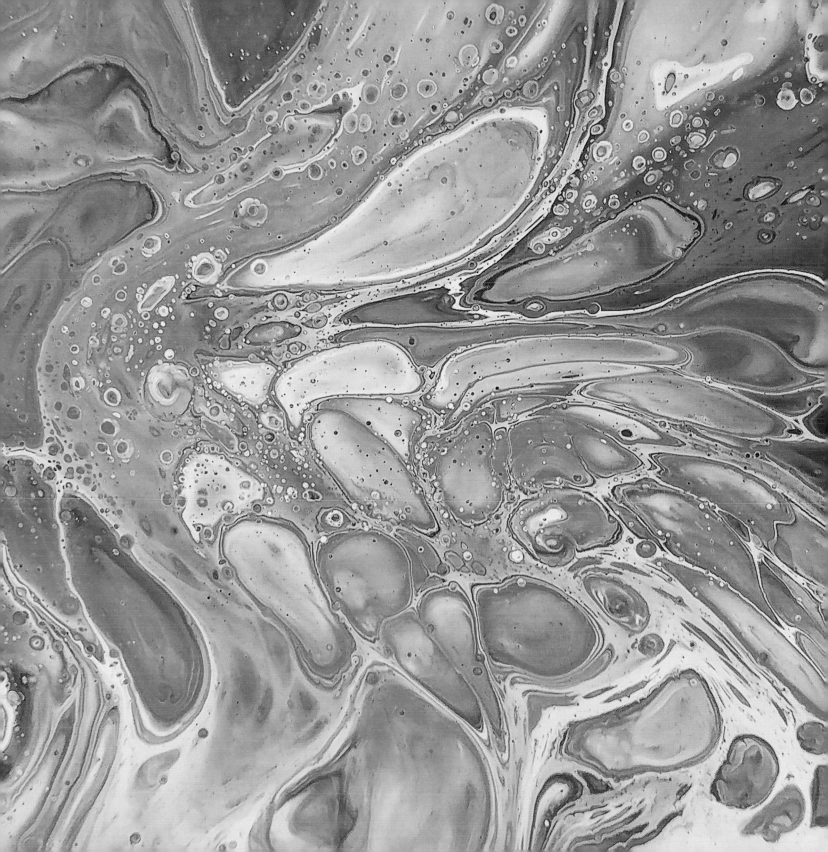

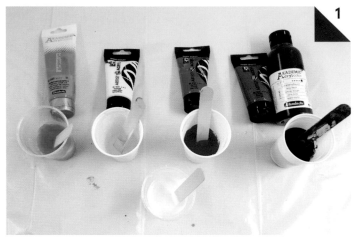

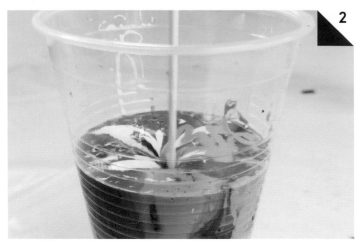

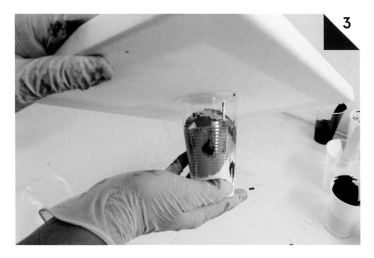

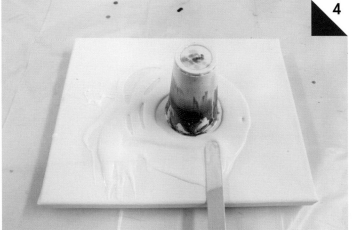

Prepare the paints in individual cups with pouring medium and add a few drops of silicone oil to each, apart from the white. To make large cells form later, stir in the silicone oil carefully with the wooden spatula. For smaller cells, stir it in more thoroughly.

Drip some silicone oil onto a paper towel and use it to wipe out the cup, so that the inside is dampened with oil. Beginning with white, pour the individual colours into the mixing cup one after the other, in any order. Do not stir the mixture!

Hold the mixing cup in one hand and place the centre of the canvas on top of it in the middle, like a lid. Now hold the cup and the canvas tightly together and turn them over – the flip! Now the cup is upside down on the canvas.

Let the cup stand for approximately 1 minute so that the paints can flow downwards. In the meantime, with the spatula or your hands, spread a coat of white around the cup to increase the flow of the paint across the canvas.

Projects

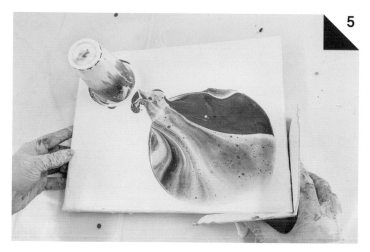

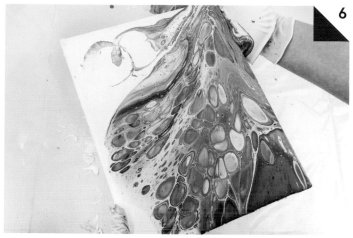

Now tilt the cup carefully and lift it slowly from the canvas. Place the upside-down cup in different areas within the white space and let rings develop with the remainder of the paint.

Using the blowtorch, remove the air bubbles by moving the flame quickly back and forth over the picture from a distance of 15–20cm (6–8in). Now take the picture in both hands and spread the paint out as desired by changing the angle.

Make sure that the paint also runs over the side edges of the picture. Fill in any blank areas with a wooden spatula, using paint that has run off the picture. When you are satisfied with the colour gradations, put the picture down again and heat it up once more with the blowtorch to boost the cells.

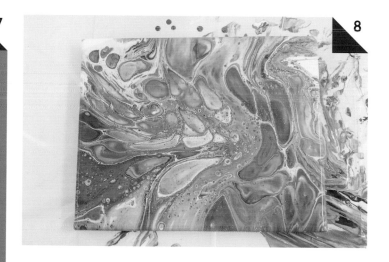

Now lay the picture flat on a level surface and leave it to dry for 3–5 days.

LIGHT AS A FEATHER

This **Swipe** project is the exception to the rule, as it should result in a figurative picture with a definite motif.

Painting surface

Canvas 24 x 30cm
(9½ x 11¾in)

Paints

Up to 20ml (4 tsp) of each colour

Dark brown
Light blue
Royal blue
Turquoise blue
White

Other materials

DIY pouring medium
Silicone oil
5 cups (4 colours and 1 white)
4 bottles with nozzles
Spatula (or a piece of cardboard
or plastic or a palette knife)
Skewer or toothpick
Long palette knife or squeegee
Blowtorch

Water
Gloves
Paper towels
4 drawing pins (spacers)
Spirit level

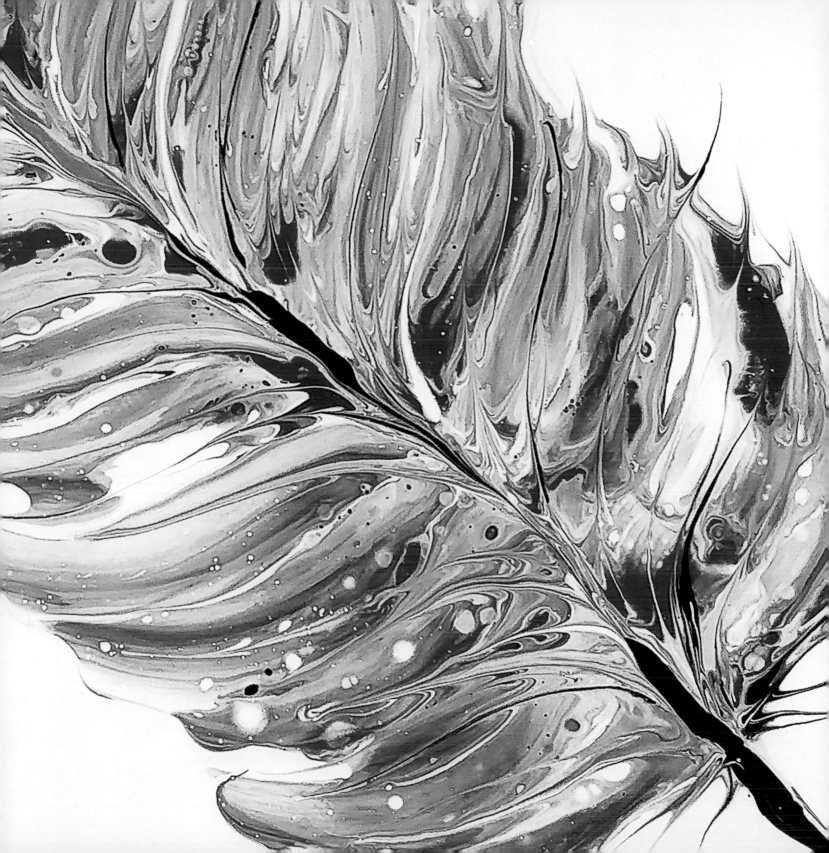

1

In one cup, prepare the white mixture with pouring medium. In the other cups, mix the individual colours with pouring medium and silicone oil. Then put the paints into the bottles with nozzles.

2

Paint a generous coat of the white medium onto the canvas, including the side edges. You can use a palette knife or your (gloved) hands for this.

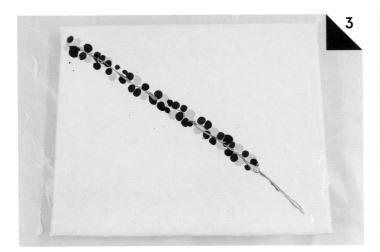

3

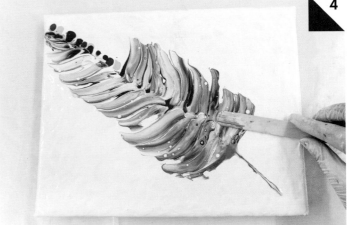

4

Using the bottle with the brown paint, draw a thin diagonal line across the canvas. Then, using the other colours, drip some little dots, left and right, along approximately three-quarters of the length of the line. The bottom right quarter is left clear.

Now, using the spatula, stroke each dot one after the other in a slight S-shape, away from the brown line and into the white background. To obtain the feather shape, make the lower strokes longer and the ones near the tip shorter.

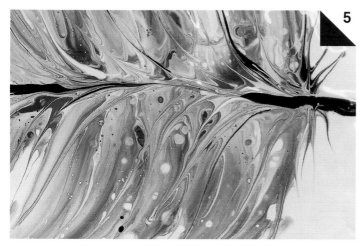

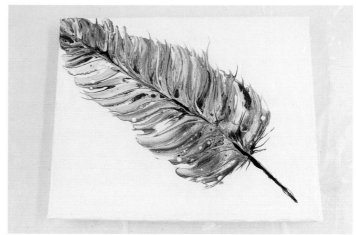

Dip a skewer in the brown paint and, using the tip, trace some individual strokes into the feather. Then remove the air bubbles by using the blowtorch over the picture from a distance of 15–20cm (6–8in).

Don't forget, the picture must be laid flat to dry, otherwise the feather will later lose its shape.

Tip

The fine lines drawn with the skewer take on an even more exciting effect if you use a black instead of brown mixture.

PERFECTION ALL ROUND

This picture looks a bit like a cross-section of the rings in a tree trunk which show the tree's age. We will create it with the Swirl technique on a round base.

Painting surface

Round MDF board,
30cm (11¾in) diameter

Paints

¼ cup of each colour

Cyan
Metallic taupe
Phthalo blue
Light blue

1 cup

White

Other materials

DIY pouring medium
6 cups (5 colours and 1 mixing cup)
5 spatulas
Long palette knife or squeegee
Blowtorch

Water
Gloves
Paper towels
4 drawing pins (spacers)
Spirit level

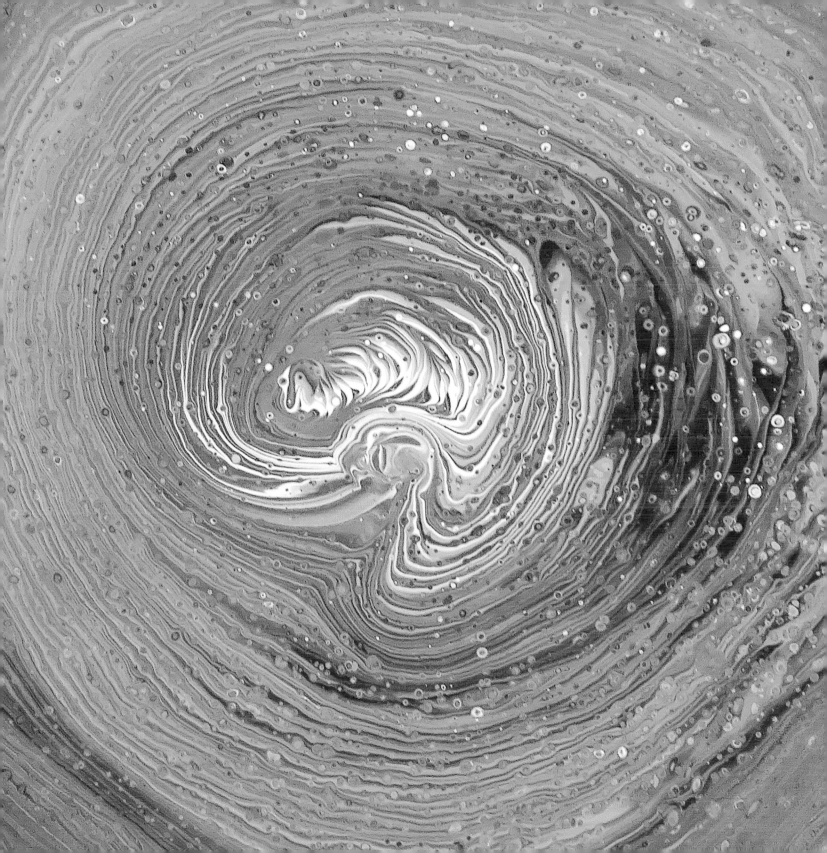

1

The round MDF board does not sit directly on the workspace but is slightly raised, for example on some jars or cups. However, it is still important that the board lies flat. It is best to check this with a spirit level.

2

Mix all four colours and the white in individual cups with pouring medium. Mix some more phthalo blue with white for a fifth colour and add some pouring medium in the same way. As an exception, **no silicone oil** is to be added here.

3

Starting with white, add the colours one after the other into the mixing cup, maintaining the same order of colours until it is full. Then pour some white onto the MDF board and spread it out. In the middle of the board, pour a white puddle.

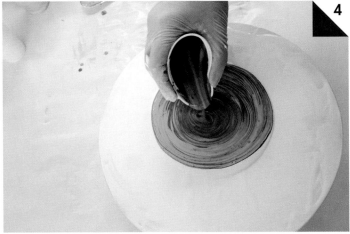

4

Aiming at the middle of the white puddle, start to empty the cup, very slowly, in small circular movements. The circles should be created by movement from the shoulder, not from the wrist.

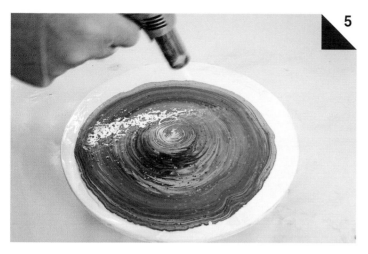

5

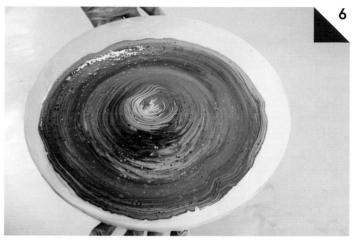

6

Remove the air bubbles by using the blowtorch over the picture from a distance of 15–20cm (6–8in).

Next, take the MDF board in both hands and change the direction of flow of the paints by tilting it.

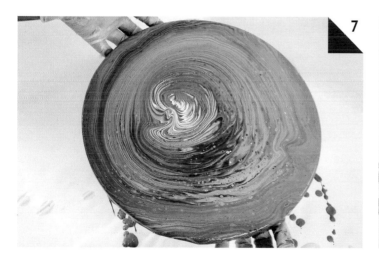

7

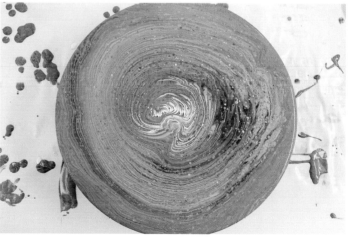

Let the paints flow over the side edges too, or fill in empty spaces with any paint that is left over or has dripped underneath.

Perfection all round! When complete, the picture just needs to dry on a level surface for 3–5 days.

PINK CYCLONE

Swirl and Air Swipe: **With the combination of these two simple techniques, dynamic shapes will emerge, reminiscent of water or lava, which will draw the eye of the beholder.**

Painting surface

Canvas 24 x 30cm
(9½ x 11¾in)

Paints

¼ cup of each colour

Sand
Flesh
English red
Copper

1 cup

White

Other materials

DIY pouring medium
5 cups
5 spatulas
Long palette knife or squeegee
Blowtorch
Silicone oil
Drinking straw

Water
Gloves
Paper towels
4 drawing pins (spacers)
Spirit level if required

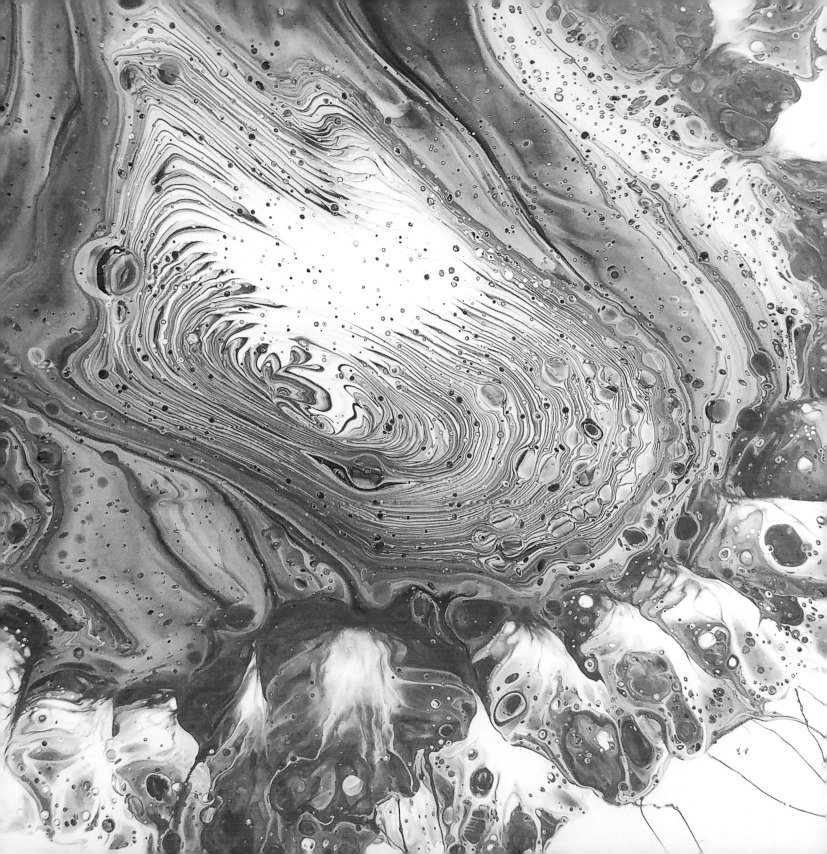

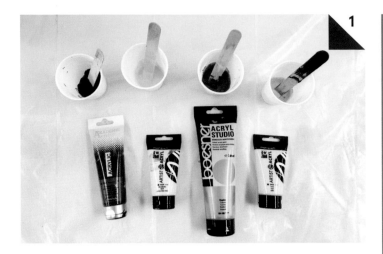

1

Prepare all the colours in cups with pouring medium. At this point, no silicone oil is used as no cells should be formed. You will also require a cup of white with pouring medium as well as an empty mixing cup.

2

Now, starting with the white, fill the mixing cup with colours, one after the other in any order until it is full. Let the colours run very slowly into the mixing cup. Then prepare the canvas with a white background: spread some white over it with your hands and pour a small puddle in the middle.

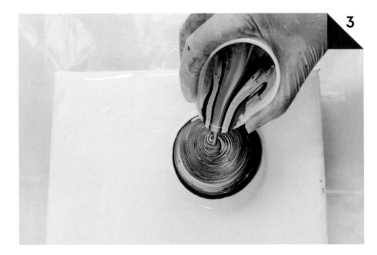

3

With a small circular movement, pour the colour mixture slowly onto the canvas, beginning at the white puddle in the middle.

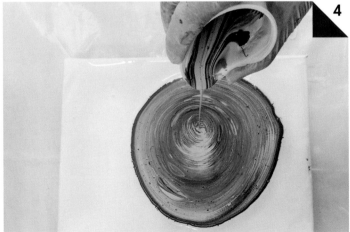

4

As before, the circular movements need to come from the shoulder and not from the wrist.

5

After you have removed the air bubbles with the blowtorch flame, add a few drops of silicone oil around the edge of the resulting coloured area. Do not tilt the canvas, as the paint puddle should stay as it was when the cup was emptied.

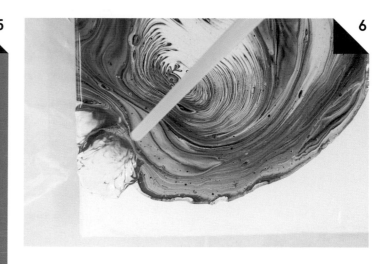

6

Take the drinking straw and, at a selected spot, blow the edge of the paint puddle which has been infused with silicone oil into the white.

7

Go around the edge of the coloured surface with the drinking straw once, always blowing outwards into the white areas.

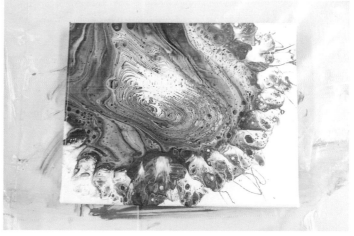

When complete, lay the picture flat on a level surface to dry.

DREAM PAIR

Dipping: One project – two pictures! You'll be creating two matching pictures which belong together and this dream pairing will really catch the eye on any wall.

Painting surface

2 canvases, 18 x 24cm
(7 x 9½in)

Paints

¼ cup of each colour

Blue
Primary yellow
Red orange
Cadmium red, medium
Light green

1 cup

White

Other materials

DIY pouring medium
Silicone oil
5 cups (4 colours and 1 white)
5 spatulas
Long palette knife or squeegee
Blowtorch

Water
Gloves
Paper towels
8 drawing pins (spacers)
Spirit level as required

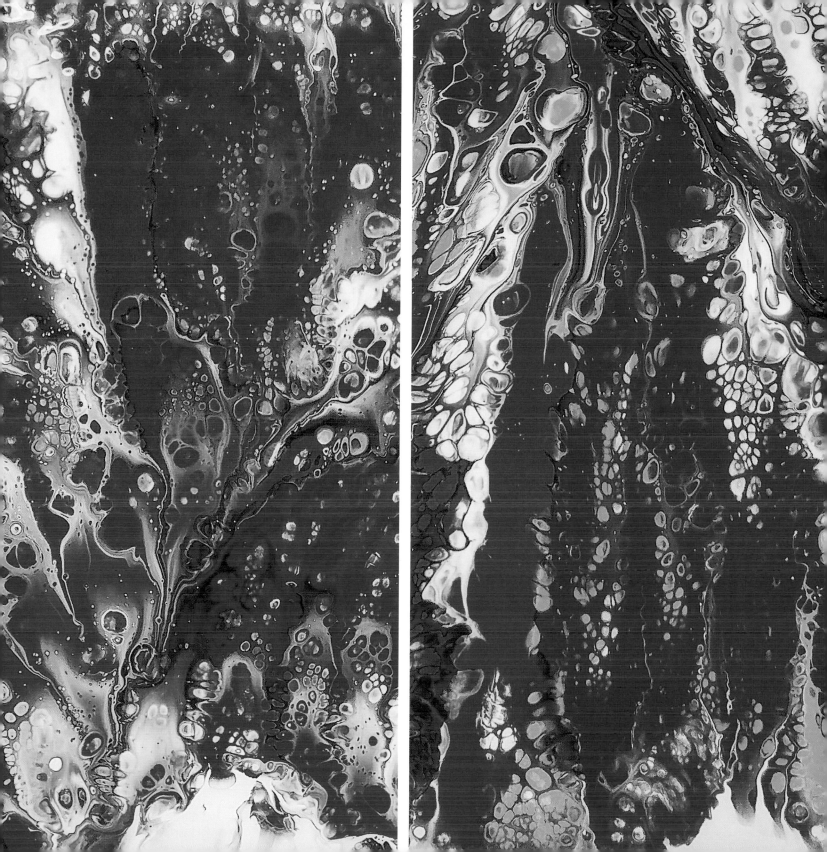

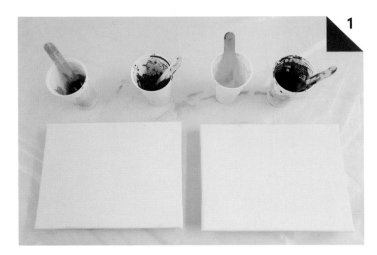

Prepare the individual colours with pouring medium and silicone oil, and have an empty cup available. Just for the white you can, as usual, dispense with the silicone oil.

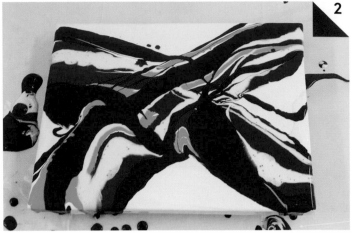

Now pour the colours one after the other onto the canvas (for example in an X shape). You do not need to keep to any kind of order. Remove the air bubbles with the blowtorch by moving the flame back and forth over the picture.

Paint the second canvas with white pouring medium, including the side edges. Lay the white canvas onto the coloured canvas and press them together.

Press the backs of the painted areas as well as the frames.

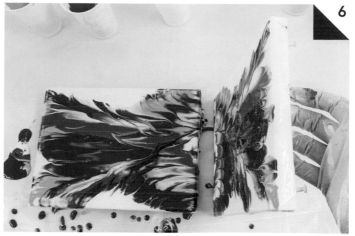

Now lift up the pictures and carefully pull them apart.

Finish off with the blowtorch at a distance of 15–20cm (6–8in), going back and forth over both pictures to remove the air bubbles and to activate the silicone oil.

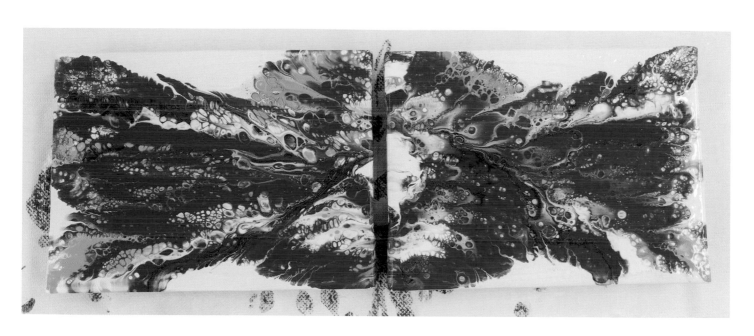

The finished pair of pictures must be left to dry for 3–5 days after completion, as usual.

PULL THE STRINGS

String: Using the string technique on a white background, you can create fascinating, strong, individual highlights!

Painting surface

Canvas 24 x 30cm
(9½ x 11¾in)

Paints

20ml (4 teaspoons) of each colour

Primary yellow
Cyan
Neon-Orange
Cadmium red, medium

1 cup

White

Other materials

DIY pouring medium
Silicone oil
4 cups (3 colours and 1 white – lots)
4 spatulas
Long palette knife or squeegee
Blowtorch
Wool, string or similar, approx. 30cm (11¾in) long
Non-absorbent paper or film

Water
Gloves
Paper towels
4 drawing pins (spacers)
Spirit level as required

1

Prepare individual cups with pouring medium and paint mixtures, including the white. Add some silicone oil to the yellow, cyan and orange. Then cover the canvas generously with white and use your blowtorch to remove the air bubbles.

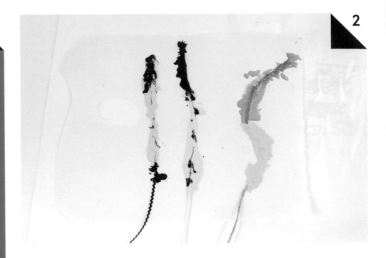

2

Arrange three pieces of string, each approximately 30cm (11¾in) in length, on some paper or film. Drip or wipe on the paint, or submerge the pieces of string into the paint cup and then lay them back on the piece of paper. Leave one end of each string without paint so that you can hold it.

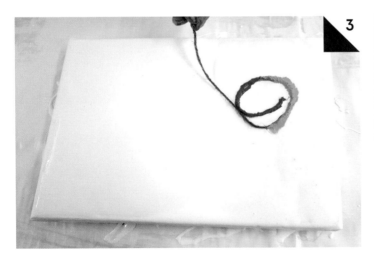

3

Lay the first piece of string in a loop on the damp white canvas, holding the dry end in your hand.

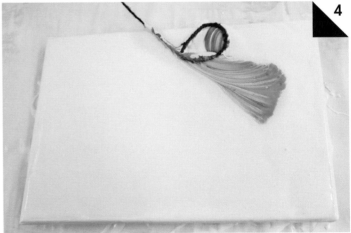

4

Pull the string slowly towards the edge of the picture.

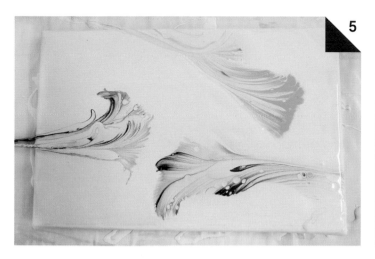

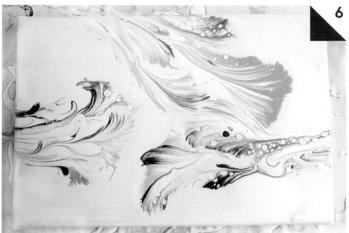

You can carry out steps 3–4 in different parts of the painting as often as you like. By using only three strings on the white background, you give each individual paint trail the space to develop to its full effect. In this case, less is more!

Finally, go back and forth over the picture with the blowtorch from a distance of 15–20cm (6–8in). This will remove the air bubbles and the silicone oil will be activated.

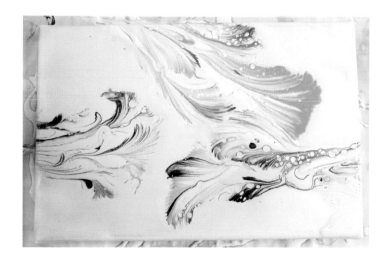

When it is finished, let the picture dry for 3–5 days. Once again, a new work of art is born!

Tip

Instead of using a white background as here, the string technique can be used on a background which has been created using another technique, such as a Dirty Pour or Flip Cup.

CRAZY RINGS
OF COLOUR

Puddle Pour: Here you will work on a black background. The name 'Puddle' may not sound very promising – but the result is stunning.

Painting surface

Canvas 24 x 30cm
(9½ x 11¾in)

Paints

Up to ⅓ cup of each colour

Red
Silver
Black

Other materials

DIY pouring medium
Silicone oil
4 cups (3 colours and 1 black – lots)
4 spatulas
Long palette knife or squeegee
Blowtorch

Water
Gloves
Paper towels
4 drawing pins (spacers)
Spirit level as required

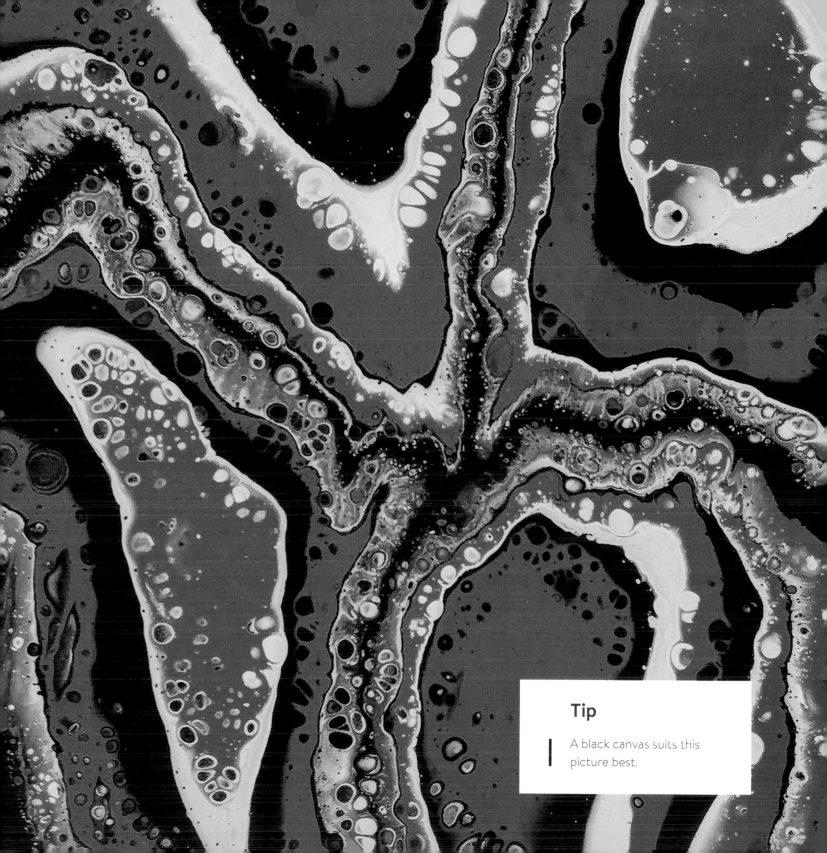

Tip

A black canvas suits this picture best.

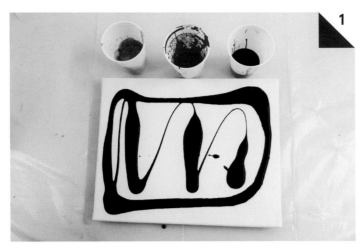

Prepare red and silver in the cups with some pouring medium and silicone oil. Do not use oil in the black. Pour the black onto the canvas and smooth it out across the whole surface with the palette knife, including around the side edges.

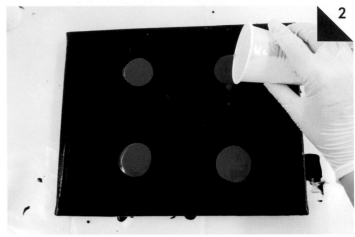

Next, pour four puddles of red onto the canvas, as though they were at the corners of a square.

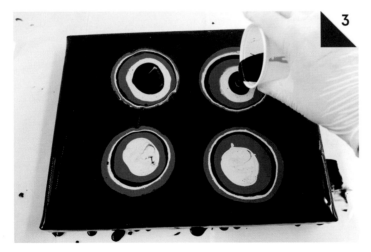

Pour silver, black and red again into the middle of the puddles, one after the other.

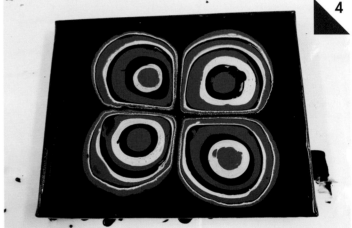

Keep on adding red, silver and black alternately, again and again until the four puddles touch each other.

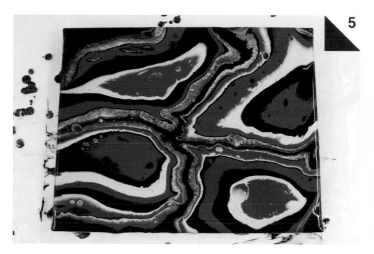

Influence the shapes and the colour gradations by taking the canvas in both hands and tilting it around until you achieve a result that pleases you.

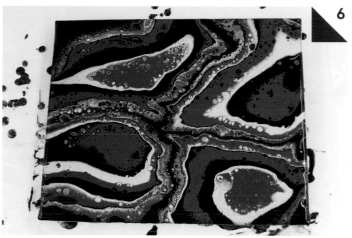

Finally, go back and forth over the picture with the blowtorch at a distance of 15–20cm (6–8in). This will remove the air bubbles and the silicone oil will be activated.

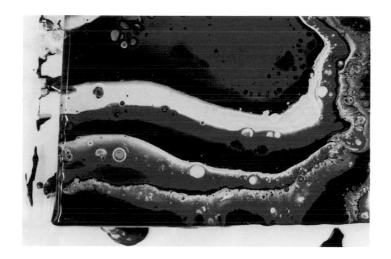

Leave to dry as usual for 3–5 days, during which time the picture should be kept on a level surface.

Tip

Puddle Pour is a technique in which you do not have to use silicone oil to achieve great results.

ALL IN ONE GO

Flip, Drag and Air Swipe: This sounds complicated but it's actually really simple! Turn the cup of paint over with the canvas and use it to draw an effective colour trail.

Painting surface

Canvas 24 x 30cm
(9½ x 11¾in)

Paints

Up to ⅕ cup of each colour

Lilac
Neon pink
Pearl rose
Pearl blue
Royal blue
White

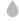

Other materials

DIY pouring medium
Silicone oil
7 cups (5 colours and 1 black – lots,
plus 1 mixing cup)
6 spatulas
Long palette knife or squeegee
Blowtorch

Water
Gloves
Paper towels
4 drawing pins (spacers)
Spirit level as required

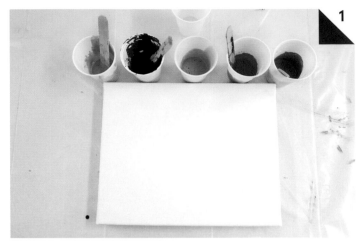

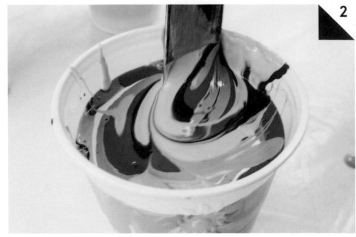

Prepare the individual colours with pouring medium and silicone oil, and have an empty cup to hand. For the white only (which you will need more of), you can dispense with the silicone oil. Rub a few drops of silicone into the empty cup.

Starting with the white, pour the individual colours slowly one after another into the cup which was prepared with the silicone oil, until it is almost full. Do not stir the mixture this time – just draw the spatula once through the paint.

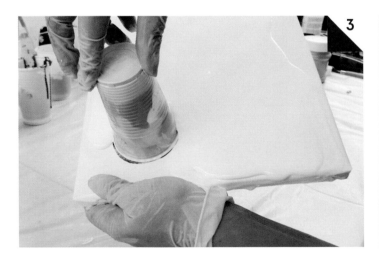

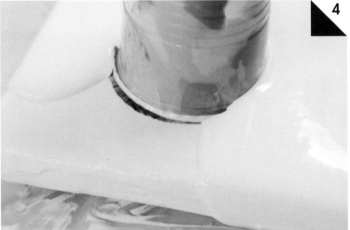

Take the mixing cup in one hand and, with the other, place the canvas on top of it like a lid. Now hold the cup and the canvas tightly together and with a gentle movement turn them over and put them down. Now the cup is upside-down on the canvas.

Now distribute a thick coat of white mixture around the upturned cup and, using the palette knife, spread the mixture over the surface of the canvas, up to the edges.

Projects

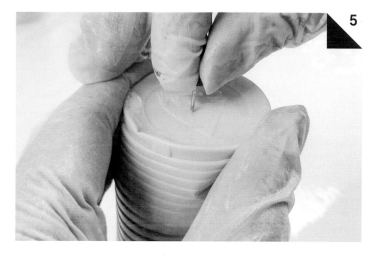

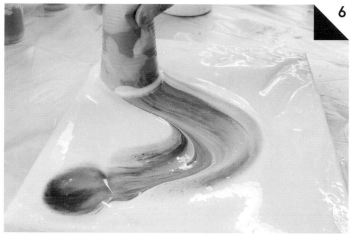

After the cup has been standing on the canvas for 1 minute and the paint has flowed downwards, make a small hole in the bottom of the cup using a pin, to regulate the air pressure.

Lift the cup up fractionally so that the paint starts to flow, and slide it gently over the canvas. Map out some wavy lines, circles or other shapes. Continue until the cup is empty.

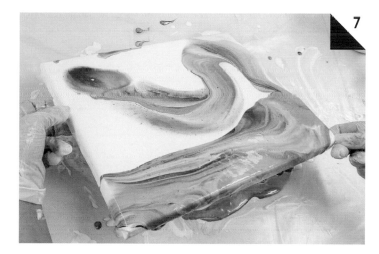

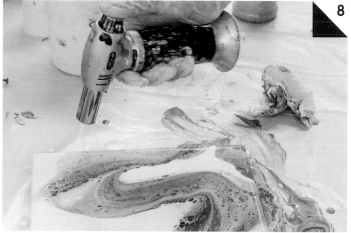

You can control the direction of flow of the poured paint by tilting the canvas back and forth. Fill in any empty spaces by using a wooden spatula with paint which has run off the picture.

Finally, pass the blowtorch back and forth over the picture at a distance of 15–20cm (6-8in) to remove any little bubbles and to activate the oil.

PAINT PUFFBALL

Air Swipe: Here we are working with individual splashes of colour rather than the whole surface. Because less paint is required, you can use the leftovers from previous projects.

Painting surface

Canvas 20 x 60cm
(8 x 23½in)

Paints

Around 20ml (4 teaspoons) of each colour

Primary yellow
Red orange
Cadmium red medium
Light green
Neon-pink
Blue
Rose (mixed from cadmium red and white)
White

Other materials

Other materials
DIY pouring medium
Silicone oil
1 spatula per colour
Long palette knife or squeegee
Blowtorch

You do not need new cups, except possibly one for a white mix.

Water
Gloves
Paper towels
4 drawing pins (spacers)
Spirit level as required

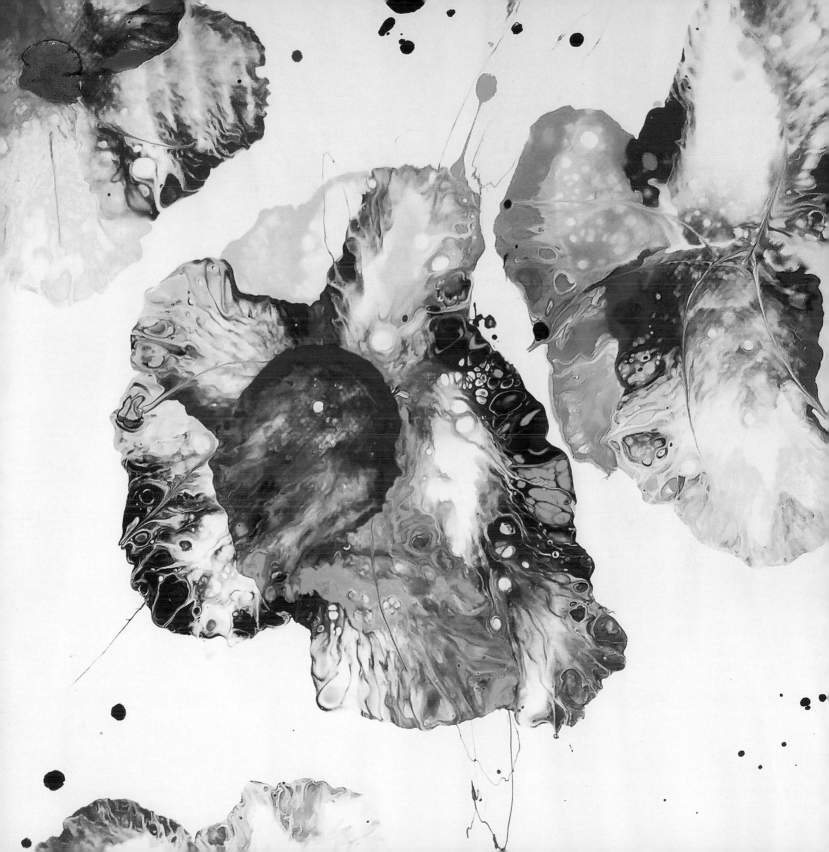

1

Prepare all the colours with pouring medium and silicone oil. If you are using paint leftovers and they have become thick, dilute them with water and add a little more silicone oil. You also need white which has been stirred with pouring medium, but not with silicone oil, to prime the canvas.

2

Cover the canvas with white, then place the first individual colour dots.

3

Take a straw and get as close as possible to the dots that you want to blow on to make them run. The nearer you get to the dots, the easier it is to control the direction of the paint.

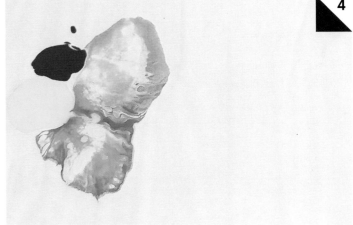

4

Now add a colour directly to the existing dots, and use the straw to blow on this one too.

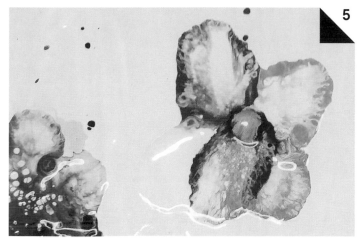

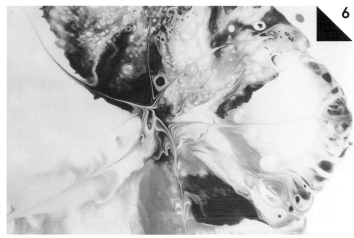

Always blow from the centre of the emerging petal to the outside. Move around your picture to do this, or turn the canvas round as you work.

You can create a great effect by using a toothpick and drawing some quick lines from the centre of the flower outwards through the petals. To finish, use the blowtorch to remove any bubbles and to activate the oil.

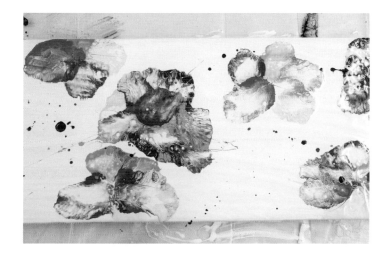

Tip

Add an additional effect by dripping black paint onto the centre of the flower and using the toothpick to draw it outwards.

After your picture is finished, lay it on a level surface for 3–5 days to dry.

FLOWER POWER

Sink Strainer Pour and Air Swipe: In this project we will create a bright, marbled flower on a white background. Instead of a sink strainer, we will use a juice extractor.

Painting surface

Canvas 24 x 30cm
(9½ x 11¾in)

Paints

Up to ⅕ cup of each colour

Gold
Orange
Cyan
Red orange
Pearl blue
White

Other materials

DIY pouring medium
Silicone oil
6 cups (5 colours and 1 white – lots)
5 spatulas
Juice extractor
Water bath (or paper towels) to place the lemon squeezer on
Drinking straw
Blowtorch

Water
Gloves
Paper towels
4 drawing pins (spacers)
Spirit level as required

Projects

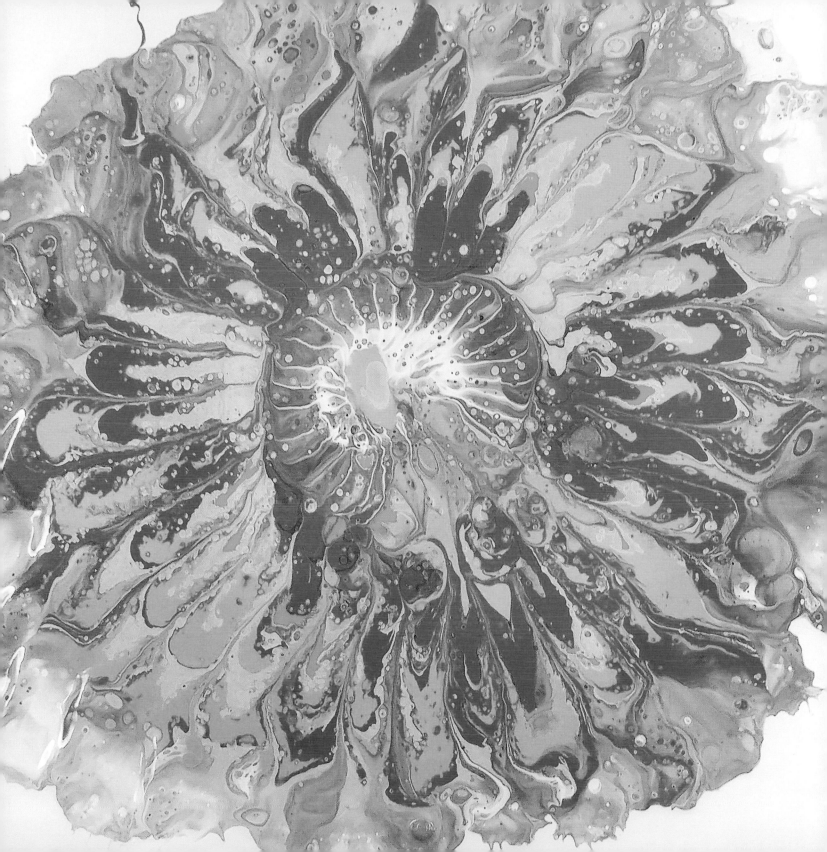

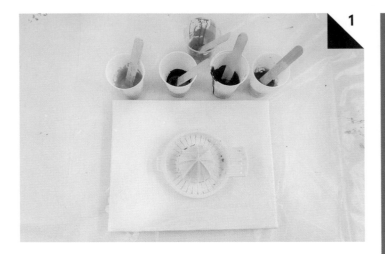

1

Prepare your paints with pouring medium and silicone oil (apart from the white). You need around a third of a cup. Have some more of the white mixture ready so that there is enough to prime the canvas.

2

Now cover the entire surface of the canvas with the white pouring mixture and smooth it over. Add another small white puddle to the middle of the canvas and place the juice extractor in this.

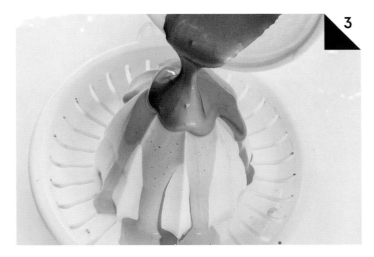

3

Now pour the individual colours one after the other onto the tip of the juice extractor.

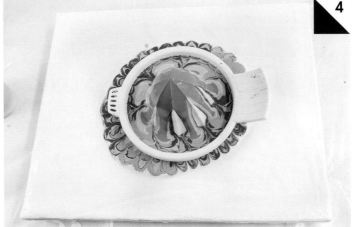

4

You can keep on adding the paint in any order, several times over. The more paint you use, of course, the larger your flower will be!

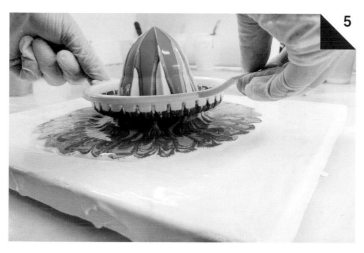

Now carefully lift the juice extractor up with both hands and lay it on the paper towels or in the water bath after use.

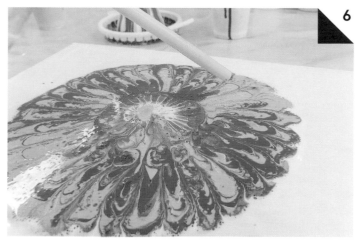

Using a drinking straw, you can carefully blow on the edges of the flower until they reach the sides of the picture, to obtain an additional effect.

Now you can modify the design even further by tilting the canvas, or go back and forth over the picture with the blowtorch at a distance of 15–20cm (6–8in) to remove air bubbles and to activate the silicone oil.

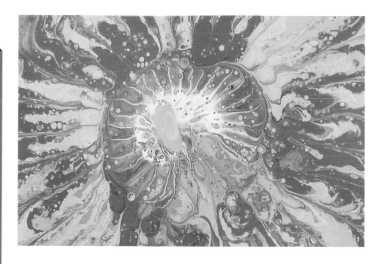

Dry the picture on a level surface for 3–5 days. You can use a sink strainer instead of a juice extractor for this technique.

NEON NIGHT

Double Swipe: For this picture, we combine the Dirty Pour and Swipe techniques. The vivid contrast between black and bright neon colours is a real eye-catcher!

Painting surface

Canvas 20 x 50cm
(8 x 19¾in)

Paints

Up to ¼ cup of each colour

Neon yellow
Neon orange
Neon pink
Neon green
Black

Other materials

DIY pouring medium
Silicone oil
6 cups (4 colours and 1 black
and 1 mixing cup)
5 spatulas
Long palette knife or squeegee
Blowtorch

Water
Gloves
Paper towels
4 drawing pins (spacers)
Spirit level as required

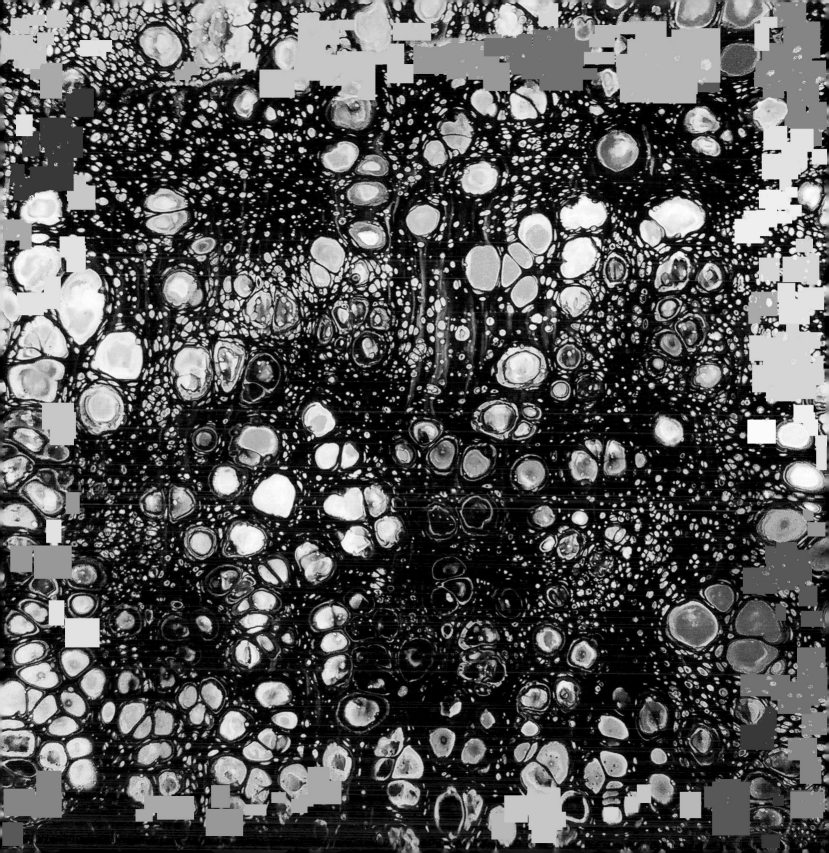

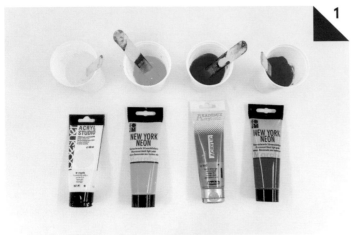

1

Pour the yellow, orange, pink and green paints into individual cups and add the pouring medium. Add a few drops of silicone oil to each colour and mix it in with the wooden spatula: stir less for larger cells and more for smaller cells.

2

The cup with the black and pouring medium mixture (with no silicone oil) should be filled a little more. Slowly pour the other colours in to an empty cup one after the other, in any order. Do not stir the mixture. Now prime part of the canvas with the black.

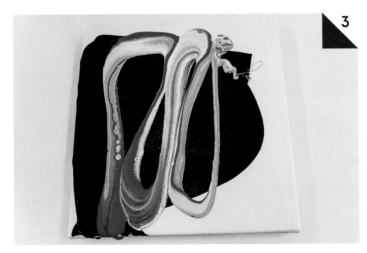

3

Now pour the colours in a wavy line over the canvas.

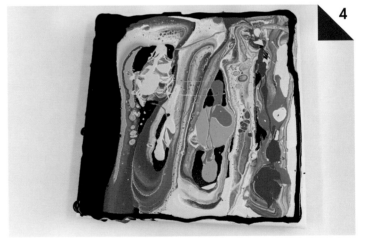

4

Add black to the remaining empty spaces. Make sure that the edges and the corners are also well covered.

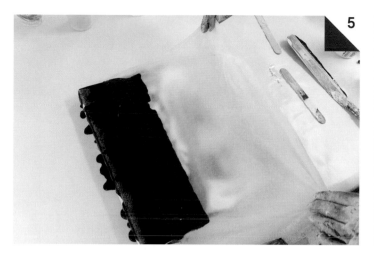

5

Remove air bubbles by rapidly moving the blowtorch back and forth over the picture. Then take a damp paper towel, place it on the black edge and draw the paint carefully to the other side of the picture.

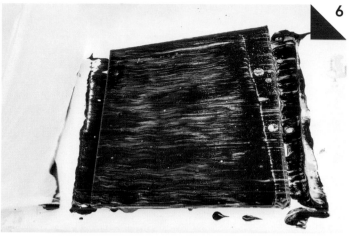

6

Now place the paper towel on the other side of the picture and draw it back again in the opposite direction. Make sure that the corners and the edges are covered in paint.

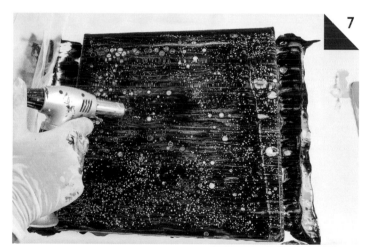

7

Go over the picture several times quickly with the blowtorch at a distance of 15–20cm (6–8in).

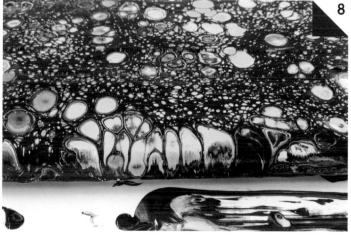

8

Carefully lay the finished picture somewhere level that has been covered over with paper. It should be dry in 3–5 days, depending on the room temperature and humidity.

COLOUR BATH

Dipping: Using the dipping technique and a combination of cool blue and turquoise shades, we create a harmonious sea of colour that you just want to dive into!

Painting surface

Canvas 25 x 25cm
(9¾ x 9¾in)

Paints

Up to ¹/₅ cup of each colour

Blue
Dark blue
Turquoise
Light green
White

Other materials

DIY pouring medium
Silicone oil
5 cups (4 colours and 1 white)
5 spatulas
Long palette knife or squeegee
Blowtorch
1 piece of film approx. 50 x 50cm
(19¾ x 19¾in)

Water
Gloves
Paper towels
4 drawing (spacers)
Spirit level as required

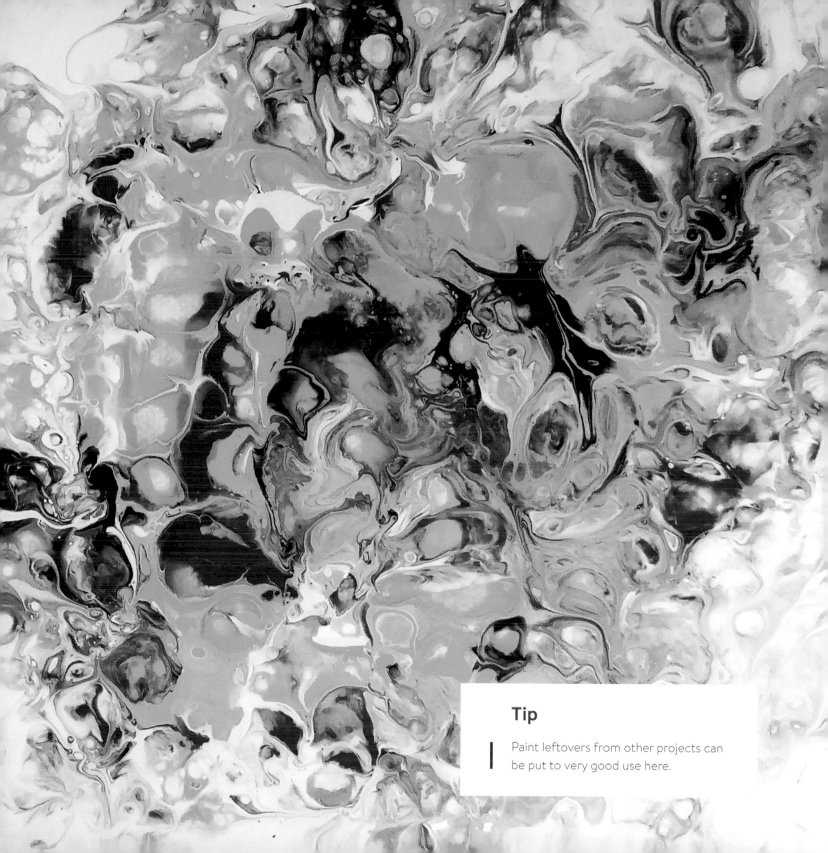

Tip

Paint leftovers from other projects can be put to very good use here.

1 Start as usual by pouring the individual colours into cups with pouring medium and a few drops of silicone oil. For large cells, stir the mixture less; for small cells, stir it more. Make up a little more of the mixture of white and pouring medium, and do not use any silicone oil in this one.

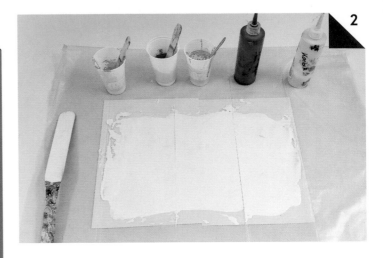

2 Now place the film (50 x 50cm/19¾ x 19¾in) on your workspace. Pour a thin coat of white on the film and spread this evenly with the palette knife.

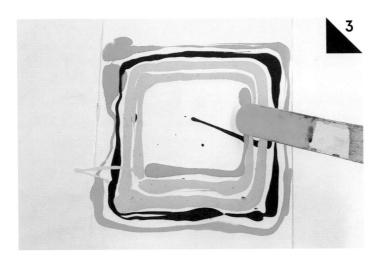

3 Now pour the colours onto the film alternately in squares of decreasing size. Do not pour the paint directly out of the cup – use a spatula.

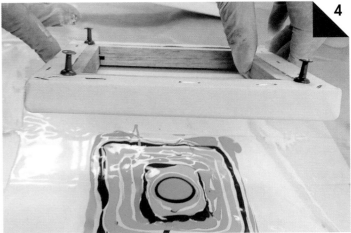

4 Take your canvas and press it front side down into the prepared area of paint.

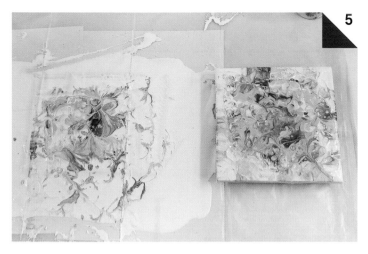

5

You can carry on, pressing it several times, until you like the result you see on the canvas.

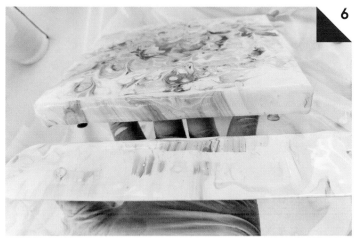

6

Take up the paint leftovers on the film with the palette knife and spread them round the edges of the canvas.

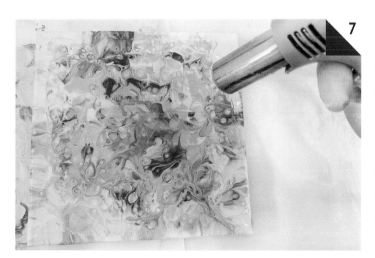

7

Use the blowtorch again to go over your picture quickly from a distance of about 15–20cm (6–8in).

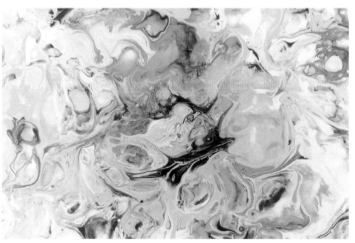

When it is finished, dry the picture as usual on a level surface for 3–5 days.

DOUBLE DIRTY CUP

Opposites attract! Create your own high-contrast picture with light and dark colours – it's very yin and yang!

Painting surface

Canvas 25 x 50cm
(9¾ x 19¾in)

Paints

¼ cup of each colour for each side

Left side:
White
Ultramarine blue
Light blue
Dark blue
Metallic dark green

Right side:
Black
Leaf green (with some white)
Light green
Primary yellow

Other materials

DIY pouring medium
Silicone oil
11 cups
9 spatulas
Long palette knife or squeegee
Blowtorch

Water
Gloves
Paper towels
4 pushpins (spacers)
Spirit level as required

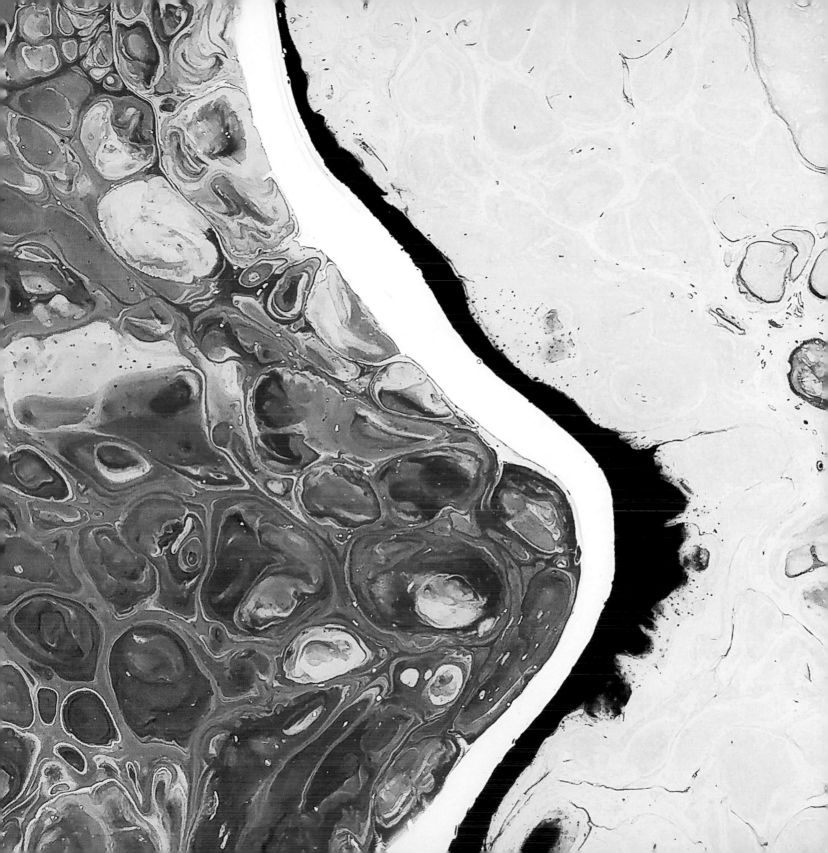

1

Prepare your workspace (see page 38, Setting up the workspace).

2

Mix each of the previously selected colours with some pouring mixture in individual cups.

3

Mix a cup each of the white and black paints with the pouring medium if you have not already done so.

4

Add a few drops of silicone oil to every colour (apart from the white and black) and depending on the desired cell formation (small or large cells), stir it in either more or less with the wooden spatula.

5

As described in the Dirty Pour project, add the colours into mixing cups. Do not fill the cups up to the top.

6

With a pencil or something similar, draw a dividing line on the canvas to help you when it comes to pouring.

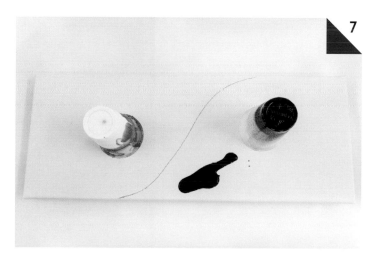

7

With two quick hand movements, turn both cups upside down, one on each side of the dividing line (Flip Cup technique).

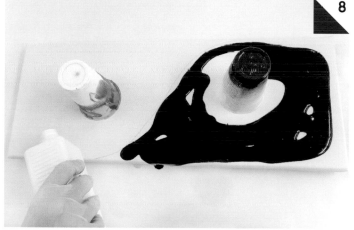

8

Now put some black and white onto the respective spaces which are still empty. Spread both equally, and in keeping with your preliminary drawing on the canvas. Make sure that you also paint the edges with each respective colour.

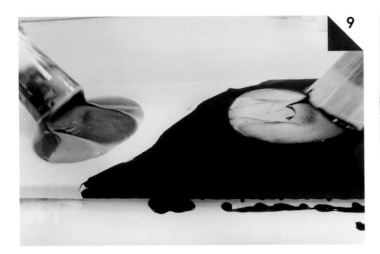

9

Now take away both cups by pulling them down sideways away from the canvas and letting the paints flow out of them.

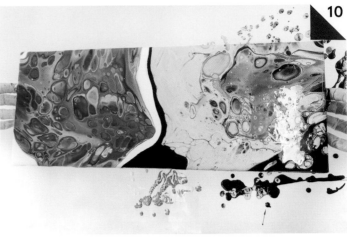

10

By tilting and tipping the canvas, you can now spread the paints evenly.

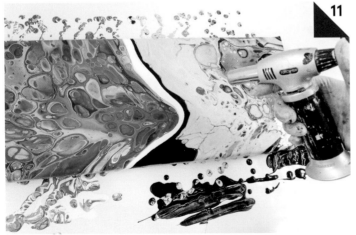

11

To finish, go over the picture several times with the blowtorch in rapid movements from a distance of 15–20cm (6–8in).

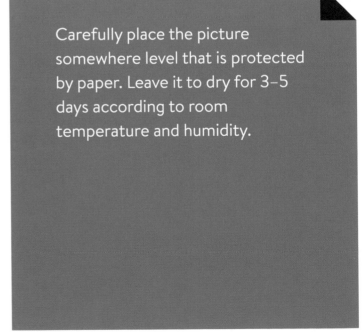

12

Carefully place the picture somewhere level that is protected by paper. Leave it to dry for 3–5 days according to room temperature and humidity.

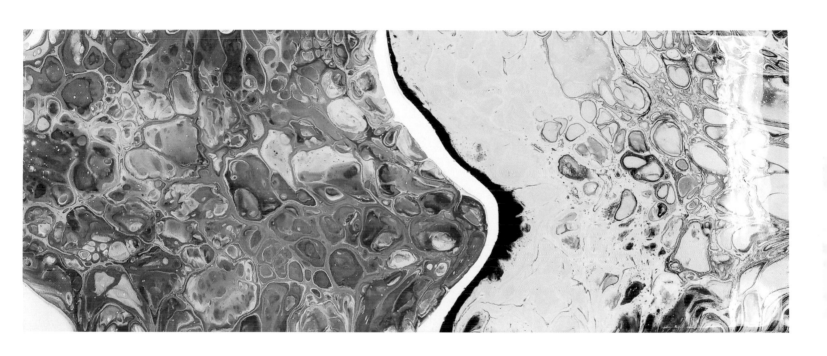

INDEX

ACKNOWLEDGEMENTS

All the lovely people who have helped me during the writing of this book should find a special mention here. I hope I have remembered everybody.

Firstly, my thanks go to my publisher, EMF. Thank you very much for the opportunity which you gave me. Our cooperation was honest and straightforward. Special thanks to Anna Egger and Anna Schmitt for their efforts and patience. I also want to thank Marabu for their generous provision of the materials and for their really excellent cooperation.

My biggest thanks go to my darling son, Tim, who had so much patience and was really a great help to me in completing the book. A big thank you also to my dear friend, Simone. Thank you for your prayers and support, especially in recent months.

It was certainly a great experience for me writing this book, and I hope very much that it won't be my last!

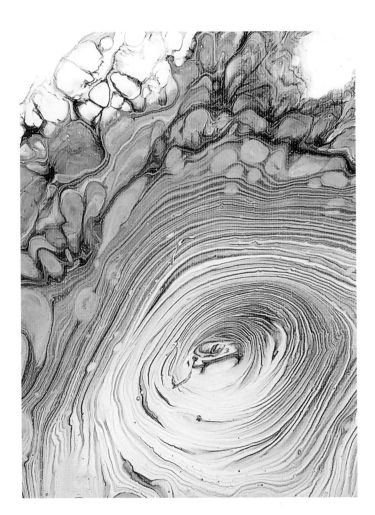

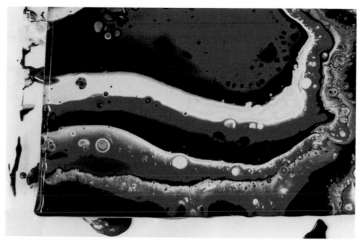

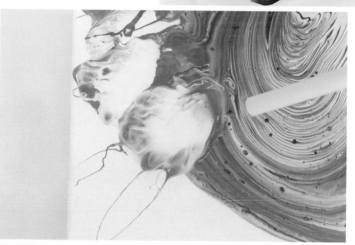

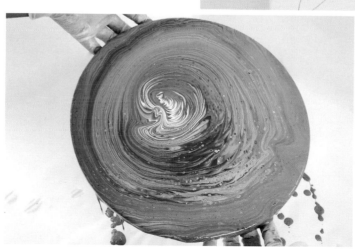

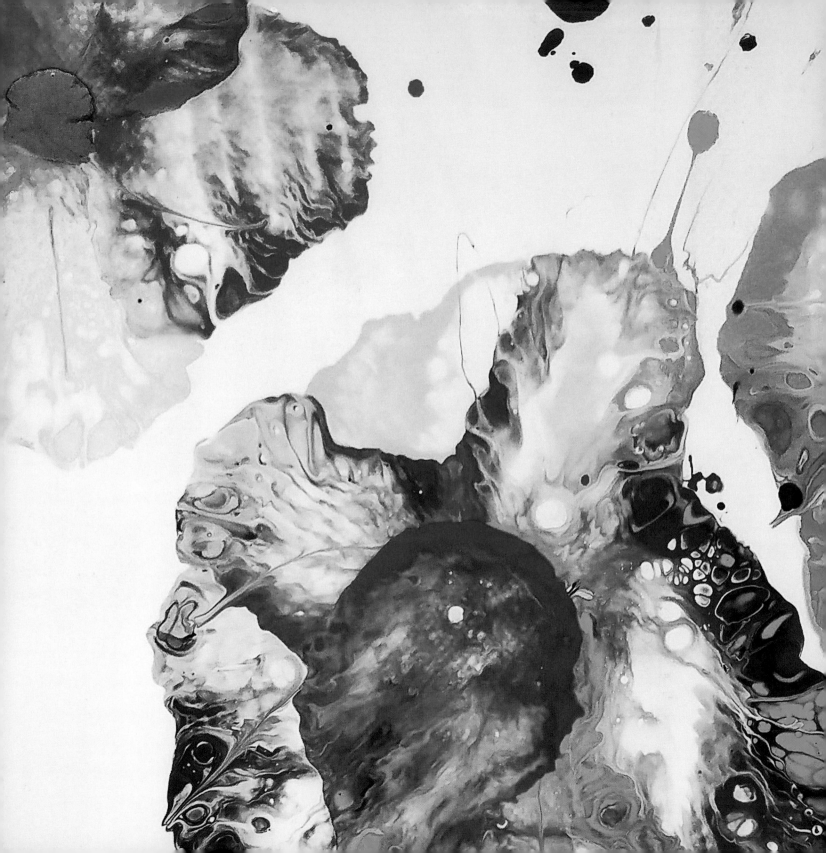